IMAGES
of America

GLENVILLE

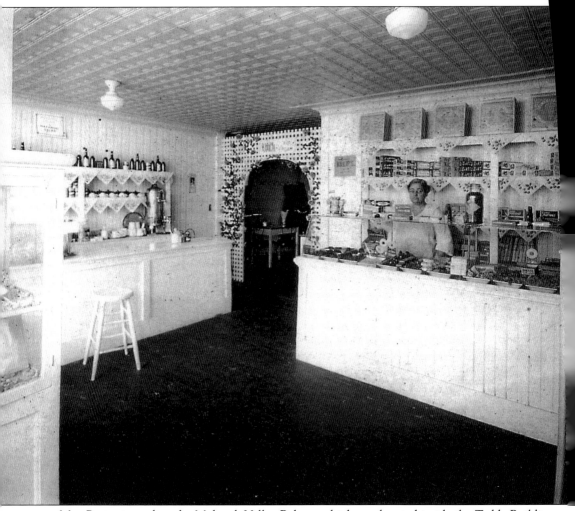

Mrs. Potter is tending the Mohawk Valley Bakery, which was located inside the Teddy Building on Mohawk Avenue.

IMAGES
of America

GLENVILLE

Schenectady County Historical Society

ARCADIA
PUBLISHING

Copyright © 2005 by Schenectady County Historical Society
ISBN 978-0-7385-3879-2

Published by Arcadia Publishing
Charleston, South Carolina

Printed in the United States of America

Library of Congress Catalog Card Number: 2005927001

For all general information contact Arcadia Publishing at:
Telephone 843-853-2070
Fax 843-853-0044
E-mail sales@arcadiapublishing.com
For customer service and orders:
Toll-Free 1-888-313-2665

Visit us on the Internet at www.arcadiapublishing.com

The seal of Glenville was found in the attic of a home on Sanders Avenue in 1963. The seal shows the profile of an American Indian and is inscribed, "Town of Glenville Seal, Schenectady County, NY." No one knows when this early seal was used. Today's seal has a picture of broomcorn (see page 127).

CONTENTS

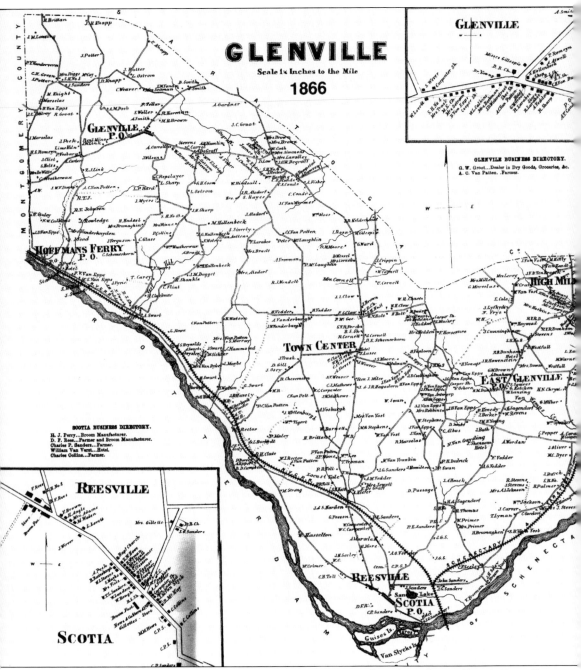

The Beers map of 1866 shows the villages of Scotia, Reeseville, Glenville, Hoffman's Ferry, East Glenville, and High Mills.

6

INTRODUCTION

The town of Glenville embraces all of Schenectady County north of the Mohawk River. Incorporated on April 14, 1820, it is, with Rotterdam, the youngest of the towns in the county, yet it had the oldest European settlement. It is named for Alexander Lindsey Glen, a native of Dysart, Scotland, who came from Holland to New Netherlands in 1639 and is believed to have been comfortably established in present-day Scotia several years before the first settlement of Schenectady in 1661. The house built by his son in 1713 is one of Schenectady County's most notable historic structures; the land on which it stands was in the same family for more than 300 years. Sander Leendertse, as the Dutch called him, and his wife are both buried in the Sanders' cemetery on Ballston Avenue. They are the only first settlers of the Schenectady Patent whose graves are known and marked.

In August 1669, the area of Glenville known as Wolf Hollow was the scene of the last great battle between the Mohawk Indians and a combination of American Indian tribes from the Hudson River Valley and Massachusetts known as the Algonkians for control of the Mohawk Valley. The defeat left the Mohawks in absolute control of the eastern end of the Mohawk Valley to the Hudson River.

When Schenectady was incorporated in 1798, present-day Glenville became the fourth ward of the city, and it remained so until 1820. It had a peculiar relation to the rest of the county, since the wooded area called Glenville Hills served as the commons. Any Schenectady resident was free to cut trees for timber or firewood there. Early in the 19th century, this common land was sold. The proceeds were divided among the county's then existing churches.

At the time that Glenville was incorporated, there were several hamlets in the town. The oldest, and probably the largest, was Scotia, which had grown up around the first Glen (later known as the Glen Sanders) homestead and had prospered by the building of the Mohawk Turnpike in the early 1800s. A little westward, where Sacandaga Road meets the turnpike, was the hamlet that had acquired the name of Reeseville and that boasted the only schoolhouse for the two communities. At the far western end of the town, where the steep road down Wolf's Hollow meets the Mohawk River, was Hoffman's Ferry (earlier Vedder's Ferry) with scow transportation across to Pattersonville. North and east, at the northern foot of the high Glenville Hills, was Glenville Village, now often called West Glenville, where the town's oldest surviving church organization, the West Glenville Reformed Church, stands. East Glenville, with a tavern, had grown up where the Charlton Stage Road branches off the Ballston Road. The falls of the Alplaus Kill, where the Ballston Road crosses it, provided power for the little settlement of High Mills. At the junction of present Spring and Swaggertown Roads where the

"Mud School" still stands was Swaggertown proper, named from the German word for brother-in-law, since nearly every house in each direction was owned by a Van Eps relative. In the 19th century, all of these settlements grew acres and acres of broomcorn, whose stiff fibers were fashioned into large and small brooms and brushes. Raising, harvesting, and storing broomcorn, as well as manufacturing brooms, constituted a major industry in Glenville from about 1835 to 1886. During this time, the town's farmers produced more than one-third of the broomcorn grown in Schenectady County.

The Mohawk Turnpike (now Scotia's Mohawk Avenue and Route 5) was the town's main thoroughfare. It was said to have a tavern for each of its 80 miles from Schenectady to Rome. The first tavern stood just north of the old Mohawk covered bridge at the beginning of a half-mile of raised road, called the Dyke, which led to Scotia. The old wooden covered bridge, designed by Theodore Burr, was Schenectady's principal gateway to the north and west and the starting point of the Mohawk Turnpike, which opened around 1800. In 1874, Glenville purchased the bridge from its owners and replaced Theodore Burr's remarkable wooden suspension bridge with an iron structure. Residents and taxpayers of the town crossed free, but all others paid the toll until about 1920. When cars began to multiply, the tolls collected by Glenville paid most of the town's expenses.

Of the onetime 15 school districts in Glenville, a few of the one-room buildings survive. The brick schools at Greens Corners and Alplaus, the latter made into a dwelling, are examples of classic red-schoolhouse architecture. District 2 built a two-room school in Scotia in 1870, doubled it to four rooms, and again to eight. But at the corner of Mohawk Avenue and Sacandaga Road stands a frame building that housed a school far older than all the others. For here, in an upstairs room, John Hetherington ran the Maalwyck School for a number of years before his death in 1803.

The Reformed church at Glenville Village was organized about 1811. The one in Scotia was organized in 1818. In 1840, both the Scotia Baptist and the Glenville Center-Methodist churches were founded. Before 1900, there was a short-lived Christian church near Swaggertown, a small hamlet, and a Methodist church at Glenville Village.

Today almost half of Glenville, apart from the onetime commons, is largely one built-up area. A generation ago, Scotia was the only part of the town that was not truly rural. Shortly before 1900, the influence of General Electric, which triggered Schenectady's growth, began to turn Scotia into a Schenectady suburb. The cornfield gap between Scotia and Reeseville narrowed and disappeared.

Agitation for the incorporation of Scotia as a village began in 1902, the year that electric trolleys crossed the bridge from Schenectady and ran up Mohawk Avenue. The New York Central Railroad opposed a village tax on its railway, causing a delay in the action of incorporation for two years. In 1904, Scotia became an incorporated village, with Dr. Herman Mynderse as its first president. Quickly thereafter, a water system, sewers, streetlights, the first paved street, a village hall, and a fire station were introduced.

By World War II, many of Glenville's residents worked in the large industrial complexes of the General Electric Company and the American Locomotive Company or in supporting areas like the U.S. Naval Supply Depot. Beginning in the 1950s, many of Glenville's old estates and farms were broken up into subdivisions and developments. Throughout the centuries, Glenville has changed, prospered, and developed. From the beginning, Glenville has been the first portal to the "Gateway to the West."

One

PLACES OF THE PAST

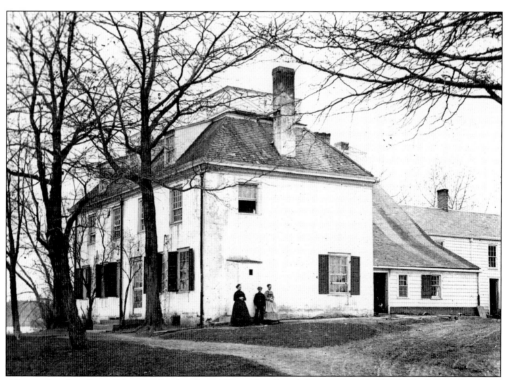

Alexander Lindsey Glen built the first Glen Sanders Mansion in 1658. Maj. John A. Glen constructed the present house in 1713. He had 13 children, 2 of whom were named Jacob and Abraham. Upon Jacob's death, his daughter Deborah Glen, who had married John Sanders, inherited the house. The house was important during the American Revolution. The Glen Sanders Mansion has served as an art gallery and is now a restaurant and inn.

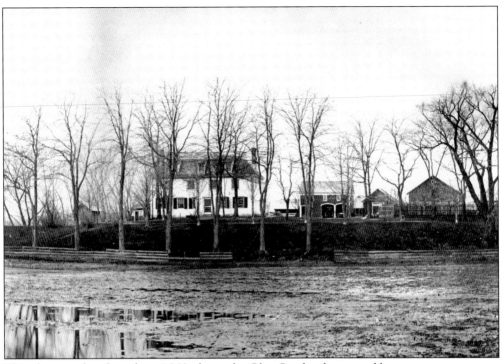

This photograph, taken about 1860, shows the Glen Sanders house and barns.

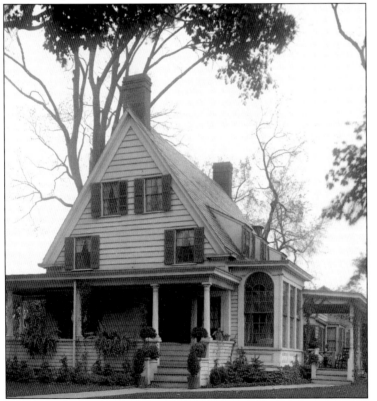

In Maj. John A. Glen's will it was stipulated that Jacob would inherit the Glen Sanders Mansion, but he would have to build a home for his brother Abraham—hence the Abraham Glen House. The house was built in 1730. The Collins family purchased the house and acreage in 1842. The Abraham Glen House remained in the Collins family until the death of Annie Collins in 1922. The house now serves as the Scotia branch of the Schenectady County Public Library.

The mustering grounds were located along the banks of the Mohawk River between the Sanders House and the Toll farm. It was used as a mustering ground by American Indian war parties, by colonial forces during the French and Indian War, by the Continental army during the Revolution, by the Mohawk Valley militia during the War of 1812, and by the Schenectady Infantry during the Civil War. Its most famous use came in September 1760, when 10,000 British and Americans camped here before marching to capture Montreal during the French and Indian War.

The Maalwyck House is on Mohawk Avenue (Route 5). Benjamin Roberts purchased the land from the Mohawk Indians in the mid-1600s. *Maalwyck* is a Dutch name for an area near Scotia. Karel Hansen Toll purchased the land and built the house about 1712. The Tolls were a competitor of David Reese in the broom-making business. This picture was taken about 1876.

11

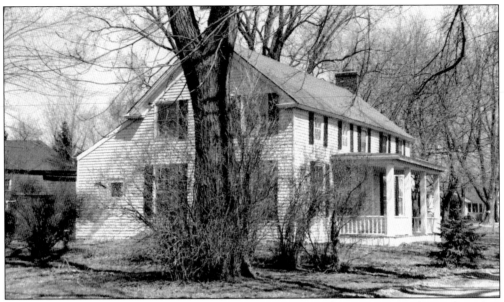

David Reese built what became known as the Flint House in the 1820s. It was located in what would later be known as Reeseville. It was a hamlet at the foot of Sacandaga Road. There was a school, seven houses, a hotel, a store, and a broom-handle factory in Reeseville. As Scotia grew, Reeseville disappeared. David Reynolds lived in the house from 1887 to 1902. In 1902, he was murdered, and his boots containing his money were taken.

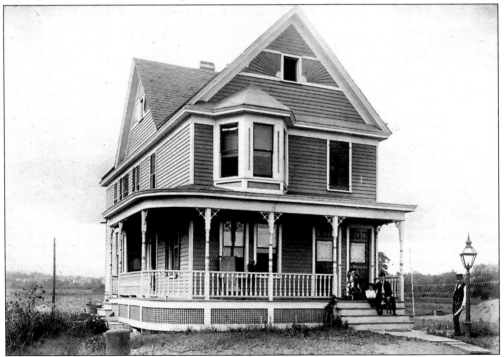

George Carver, a buyer of men's clothing at Barney's department store in Schenectady for 50 years, built this house at 16 Washington Avenue. This picture was taken about 1900. Collins Lake can be seen behind the house.

Veeder's Fort, built in 1745, had walls made of stone and a roof made of wood. It was located at what is now Vley Road and Halcyon Street in Scotia.

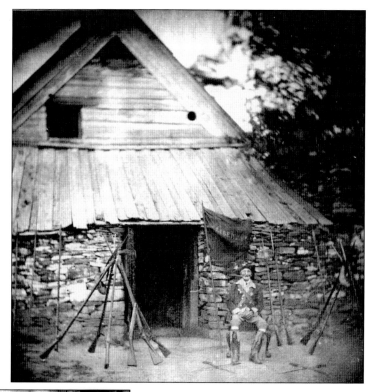

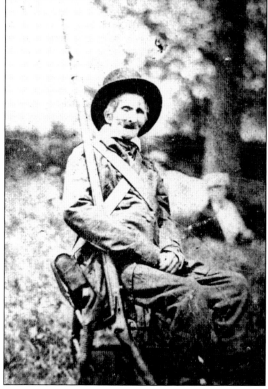

Nicholas Veeder was born in 1761 in the Hoek, an area that later became known as Reeseville. He was Schenectady County's last surviving Revolutionary War veteran. He died on April 7, 1862, and was over 100 years old.

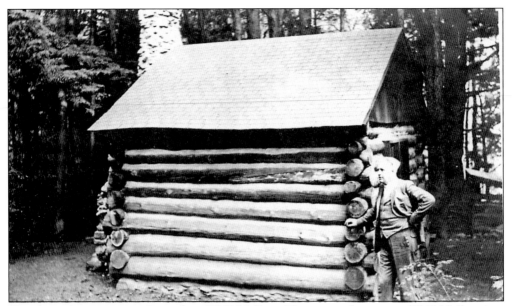

This log cabin was once located at Wolf Hollow. The ravine known as Wolf Hollow is a displacement of 1,000 feet in the earth's surface rocks caused by the fault known as the Hoffman's Ferry Fault. Interesting fossils can be found in the dolomite and shale rocks. Here, in 1669, the Mohawk Indians ambushed their Algonkian invaders in a bloody battle. The Algonkians lost 50 warriors as well as their chief. The leader of the Mohawks was Kryn. He was also the leader of the 1690 massacre in Schenectady.

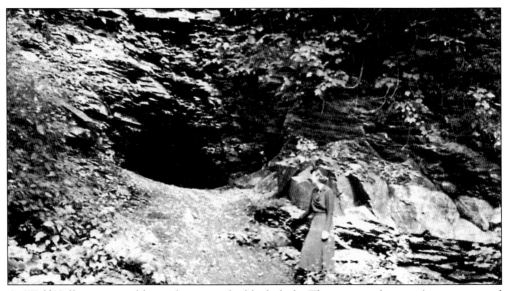

At Wolf Hollow is a cavelike coal mine in the black shale. The man-made tunnel was excavated in 1884 in a mistaken search for coal deposits.

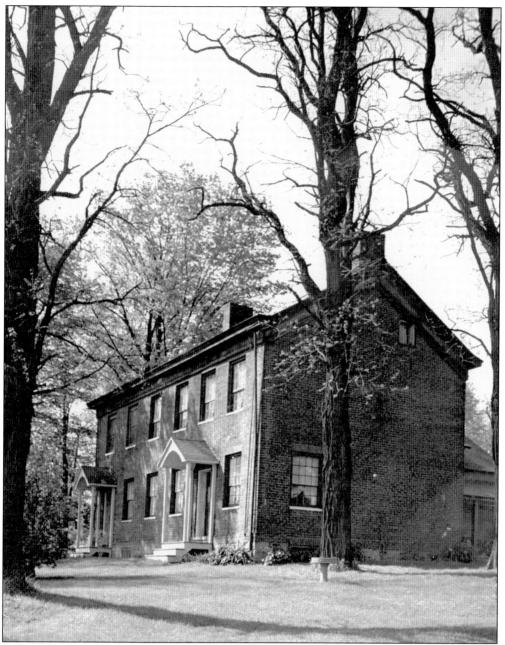

The Swart Tavern is on Route 5 near Johnson Road. Teunis Cornelius Swart signed the original petition for the land. The house was built about 1792 or earlier. The tavern had two entrances, one to the taproom and another to the home. De Witt Clinton visited here in 1810 and wrote about it in his diary.

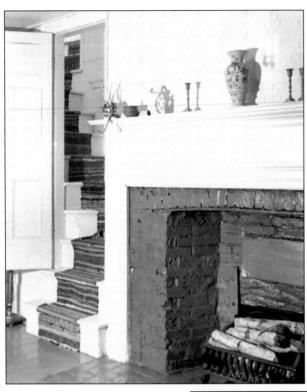

This picture shows the steep and narrow staircase in the Swart house. Handmade doors and woodwork are still in excellent condition. Pine plank floors are one and a half inches thick.

Charles Proteus Steinmetz was born in 1865 in Breslow, Prussia, now part of Poland. He immigrated to the United States in 1893, later moving to Schenectady. He developed the theory of hysteresis, which is used in electrical equipment, while he worked for the General Electric Company. Steinmetz became school board president in 1911. During his service, three new schools were built or started and two others enlarged. He was a professor of electrical engineering at Union College. He died in 1923 at his home on Wendell Avenue in Schenectady.

Using a canoe, Charles Steinmetz worked during the summer months at his camp on the Mohawk River near Scotia. Boards across the gunwales served as a desk, and he knelt on a cushion, enabling him to work undisturbed.

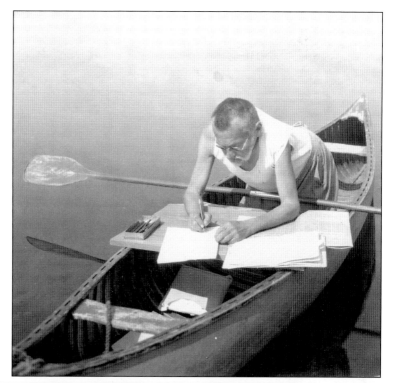

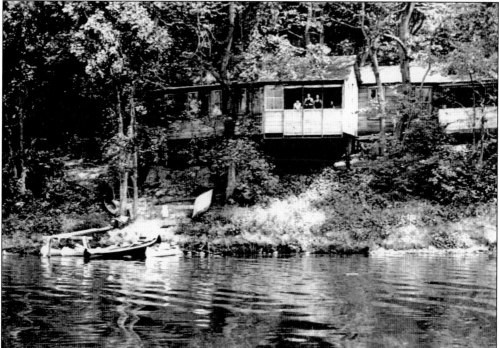

Steinmetz rented the land for Camp Mohawk from Fred Fagle. Supposedly, Steinmetz paid for the lumber for the camp himself. The camp was located on the Mohawk River west of Scotia on Route 5.

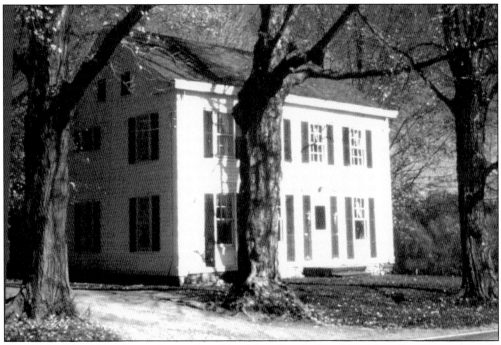

This is the Van Vorst home, located on Van Vorst Road. The Van Vorst families were early settlers in the area. Ten generations of Van Vorsts have owned this farm and still operate it today.

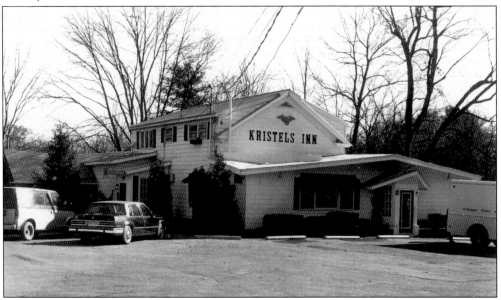

The Heckler family, who operated gristmills and cider mills on the property, built the present-day Mill Stone Lodge in 1837. It was purchased by Stefan Kristel in 1926. The lodge was a speakeasy until it was raided and closed down in 1931. The building reopened as a restaurant after the repeal of Prohibition. George and Marge Kristel bought the restaurant in 1960 and ran it as a banquet house. Until recently, the Crofts managed the establishment as a family-style restaurant. It was sold in 2005.

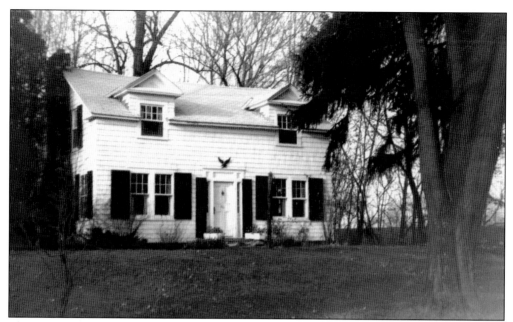

The Calderwood home, on Swaggertown Road, was built before 1854. Some of the bubbly panes of glass remain. Children living in the area had to walk to school, either to the Thomas Corners school or the high school on First Street in Scotia, both long distances from Swaggertown Road.

Cornelius S. and Sarah Conde gave this property to Roswell Larrabee in 1855. A store and a home were located on the two acres. The dwelling was destroyed by fire in 1893. Over the store, was the headquarters of the 26th Regiment of the New York State Militia, which was organized in 1857. In 1863, the store became the headquarters of Company G of the 83rd Regiment of the National Guard. Ten years later, owner Edmund Tobey made the building into a residence.

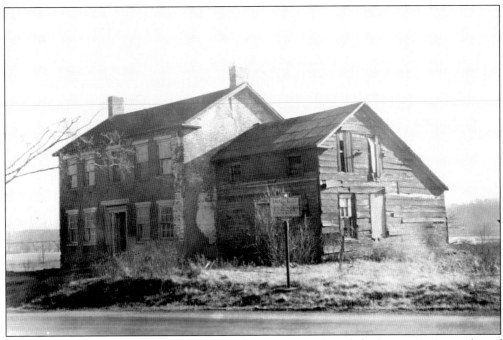

Jonathan Stevens built a house in 1693 on this land. It was demolished in 1860. A member of the Stevens family built another house in 1869. It was torn down in the late 1930s, ending two straight centuries in which the Stevens family occupied this land. A historic marker on Maple Avenue shows its location.

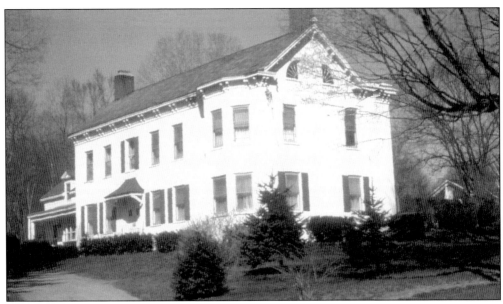

Joseph Yates built the Yates farm in 1737. Here Joseph's eldest son, Christopher, was born in 1737. Christopher was a surveyor and worked on the fortifications at Saratoga in 1777. He was the father of Gov. Joseph Yates.

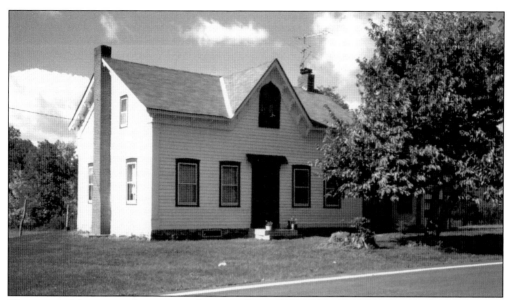

The original house in this picture dates to about 1799. The 1866 Beers map shows that the property was owned by Mr. Green. He added on to the house in 1874. John Dick purchased the property in 1920 and altered the building. It is located in West Glenville.

Written on the Beukendaal Battle Monument is the following inscription: "In memory of the men who were killed in this ravine in the Beukendaal Battle on July 18, 1746 by the Canadian Indians. John A. Bradt, Johannes Marinus, Peter Vrooman, Daniel Van Antwerpen, Cornelis Viele Jr., Nicholas DeGraaf, Adrian Van Slyck, Jacob Glen Jr., Adam Conde, J. P. Van Antwerpen, Frans Van Der Bogart, Captain Daniel Toll who were citizens. Also Lieutenant John Darling and seven Connecticut soldiers stationed at Schenectady."

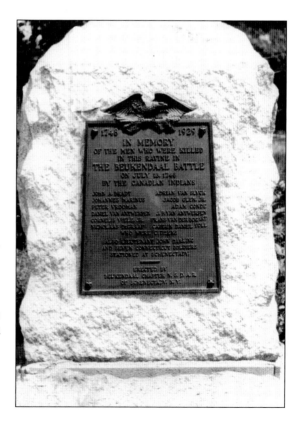

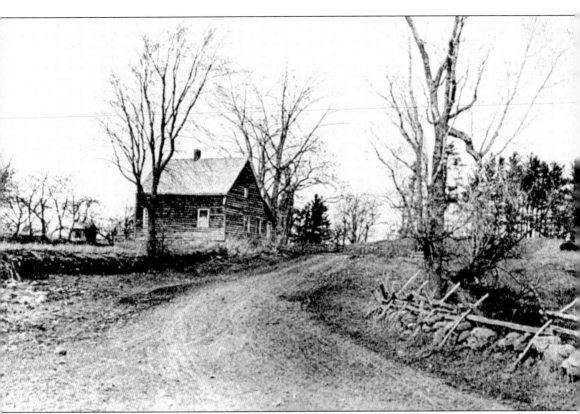

Claas Andres DeGraff had 10 children, 5 of whom were boys. Around 1700, the family moved to Scotia, where they owned an extensive amount of property. Abraham DeGraff, one of the sons, moved to Beukendaal about 1746. The photograph from a glass-plate negative shows the Abraham DeGraff house. The house no longer exists.

Two

BROOMCORN

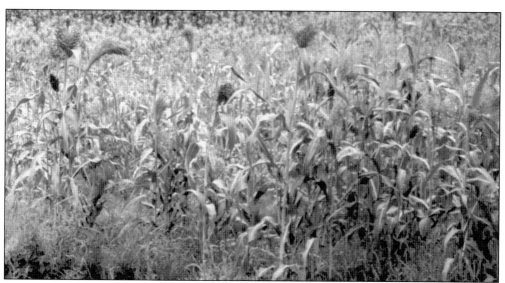

Broom making was an important industry in Glenville through most of the 19th century. Broomcorn fields were located along the Mohawk River, extending from Scotia to Hoffman's Corners. This is a view of a broomcorn field at the Beukendaal battle site.

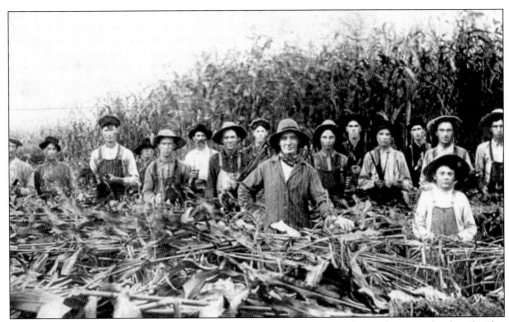

Field hands bend the tall stalks about two feet from the top and cut them at the bend. The broomcorn is then loaded on to wagons ready to go to the factories. Many factories were located on the owners' farms.

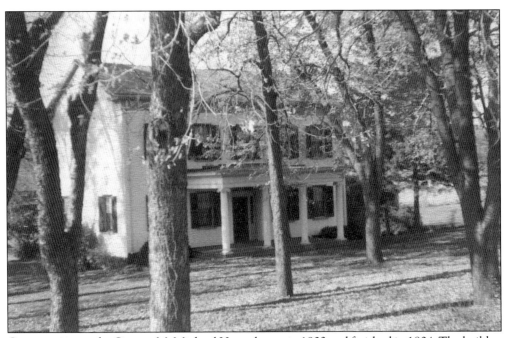

Construction on the Cramer-McMichael House began in 1803 and finished in 1804. The builder, James Boyd, filed for bankruptcy during this time. The farm was sold to William Cramer, who became the second owner. Cramer had nine children. Ruth, one of the children, married John McMichael, and the house has remained in their family since that time.

All of the original buildings are still standing on the McMichael farm today, including the well house above. Broom making was done on the farm during the 1800s. By 1900, the land was converted into a dairy farm, and in 1940, the farm raised beef cattle. People often came to gaze at the Angus cows, thinking they were buffalo.

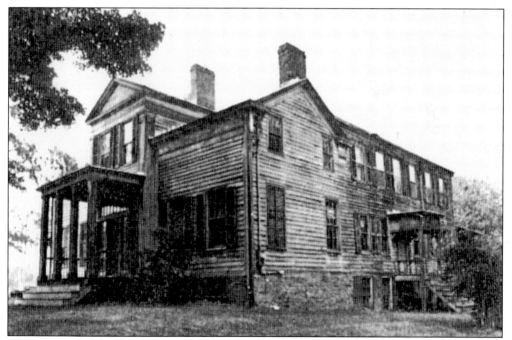

The John H. Seeley farmhouse, on Freeman's Bridge Road, was built in the mid-1800s and is on the National Register of Historic Places. This came about through the efforts of a Glenville citizens committee. The building was chosen for historical and architectural reasons.

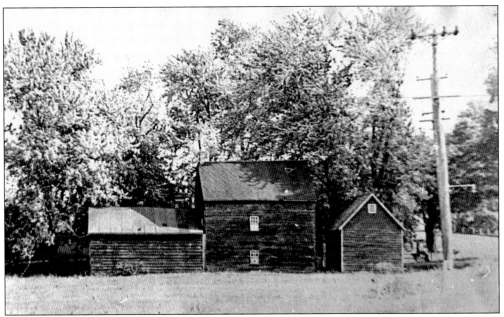

The Seeley barns were used in the broom-making business. During the 1800s, Schenectady and its environs were called the "Broomcorn Center of the World" because half of the crop for the state was grown in Schenectady County.

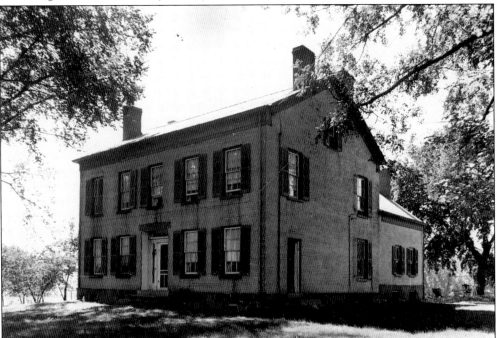

The rear of the Barhydt House was built before 1756, while the front two stories were added about 1825. This house is located on Route 5 (formerly the Mohawk Turnpike) west of Scotia and served as a turnpike tavern. In the 1920s, it was a speakeasy. John S. Barhydt was one of the large growers of broomcorn and manufacturer of brooms. His son John Barhydt and later his grandson Chauncey carried on the business.

Descendants of the Barhydt family—Etta Barhydt Larrabee, Etta Larrabee Dawson, John Dawson, and Helen Dawson Mabee (age three)—pose in front of their house on Badgley Road in Scotia. The house was built from a 1922 Sears house kit.

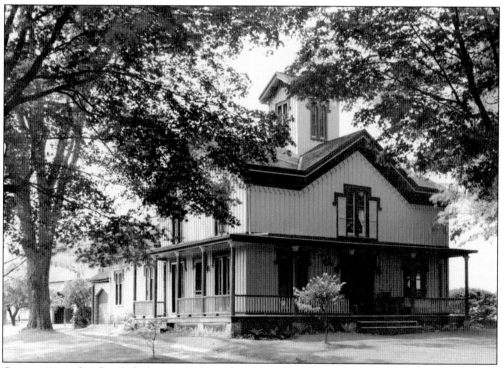

Construction for the Cole homestead was begun prior to 1850 by Ephraim Cole. The house has vertical board-and-batten siding. The beautiful, stately house was built to oversee the acres of broomcorn and the factory that made brooms. It is located on the corner of Van Vorst and Charleton Roads.

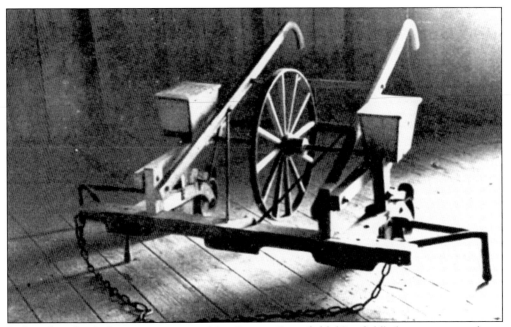

Before the wheel planter was invented by George Campfield (Canfield), broomcorn seed was planted by hand. It took from six to eight quarts of seed to plant one acre. The wheel planter deposited seed at uniform distances, making it unnecessary to thin the young plants. The above picture shows the planter that was used on the McMichael farm.

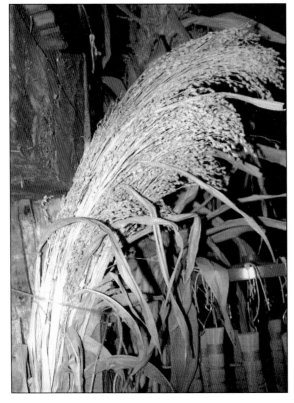

This is a panicle of broomcorn. The stalk bears no ears of corn but rather a flowering bush of stiff fibers.

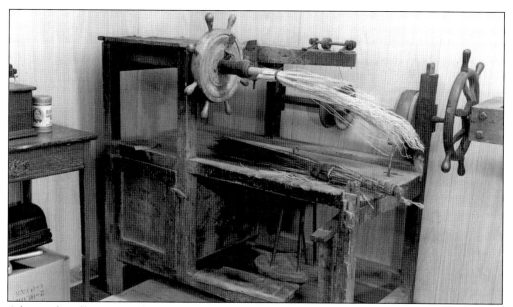

A broom handle is secured on this machine, and panicles of broomcorn are attached by winding wire around the handle as it is rotated. George Campfield (Canfield) is alleged to have invented many machines used in broom making. However, since he had none of these machines patented, many of his ideas were pirated.

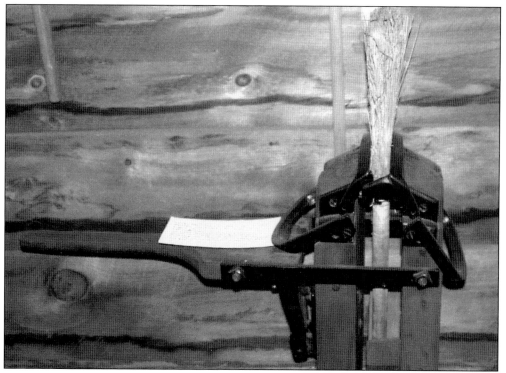

This machine flattened and sewed the brush. The heavy cordlike thread was stitched using a needle eight inches long. Parlor brooms had the longest and straightest panicles, and as a decorative touch, bright velvet was added beneath the last stitching.

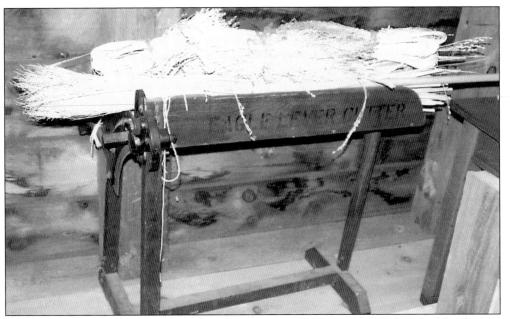

The broom was put in a trimmer with a sharp cutter. The broom could then be bleached by sulfur fumes or dyed.

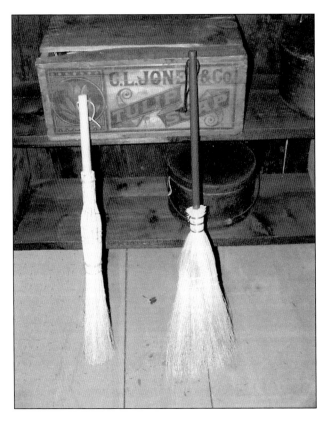

Round brooms were known as hurl or hearth brooms. Flat brooms were known as Shaker brooms.

Three

HOMESTEADS

The wedding of Helen Mynderse and Edwin McClellan was held at the Mynderse home in August 1904. Dr. Barent A. Mynderse had three children—William T. B., who married Sarah Wilson; Herman, who married Helen Douw; and Helen, who married Edwin McClellan.

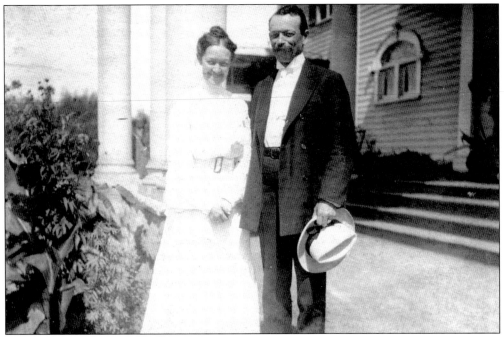

Edwin and Helen McClellan are visiting Lake Hill. Lake Hill was so named because it was built on a hill that overlooked Collins Lake. Herman and Helen Douw purchased the home in the 1890s.

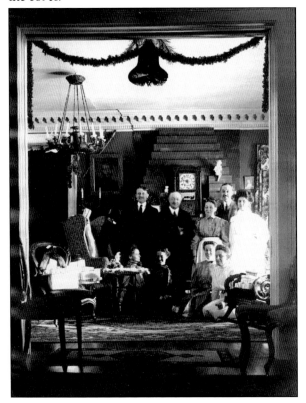

The Mynderse family celebrated Christmas at their Lake Hill home. Seated, from left to right, are unidentified, Helen M. McClellan, Sarah Mynderse, and Helen D. Mynderse. Standing are Charles Douw, Herman Mynderse, Mary Silery (servant), William T. B. Mynderse, and unidentified. Herman was a well-known physician. William T. B. Mynderse was a noted architect.

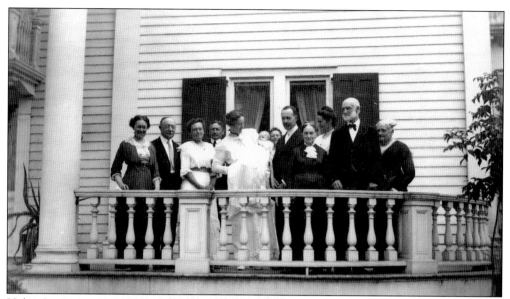

Helen Livingston Mynderse was christened on June 28, 1914, at Lake Hill. From left to right are Helen M. McClellan, Herman Mynderse, Helen D. Mynderse, Charles Douw (Helen's brother), Sarah Mynderse, baby Helen, unidentified, William T. B. Mynderse, Anna McClellan Mynderse, Anne Wilson, Harold Wilson, and M. E. L. S. Wilson. Helen Livingston was the only child of Sarah and William. Helen died at the age of 76 in 1990. She had never married, so she left an estate of $6 million to charities.

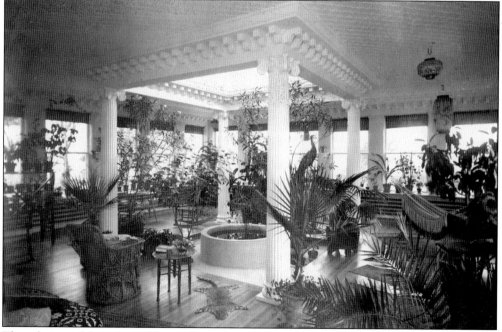

The solarium of the Lake Hill home shows the indoor garden of tropical plants and the decorative pool. William Mynderse was an architect and designed this home, Holland House, and many other significant structures of the time. Lake Hill was demolished to build the First Reformed Church Hall about 1954.

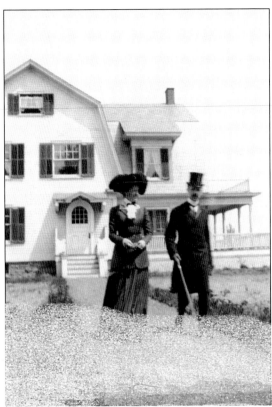

Sarah and William T. B. Mynderse are shown in front of 19 Sunnyside Road just before moving into Holland House. Holland House was closer to Lake Hill.

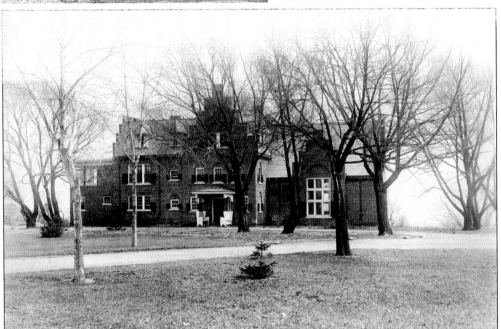

Holland House was patterned after Washington Irving's home in Tarrytown, New York. The Tudor-style living room has a 30-foot ceiling. The fireplace includes historic delft tiles from the 17th century.

The wedding certificate of Percy M. Van Epps and Margaret Van Vranken shows that they were married on January 1, 1890. Percy Van Epps was the first Glenville town historian, appointed in 1926. In 1929, he was appointed the first county historian.

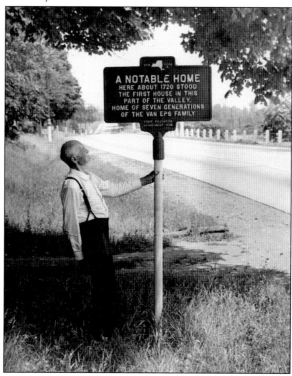

Percy M. Van Epps admires the historical marker placed in front of the family farm in Hoffmans. He was a musician, historian, archeologist, paleontologist, and in his spare time, an agriculturalist. He was recognized in the eighth edition of *Who's Who in America*. His family roots go back to 1669 in the Stockade in Schenectady.

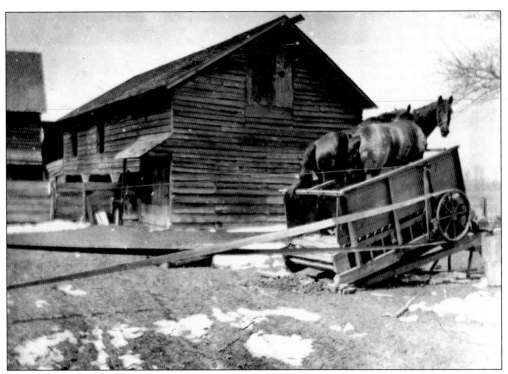

Horses work a treadmill attached to a belt that powers a threshing machine. This machine was on the Van Eps farm on Touareuna Road in Glenville.

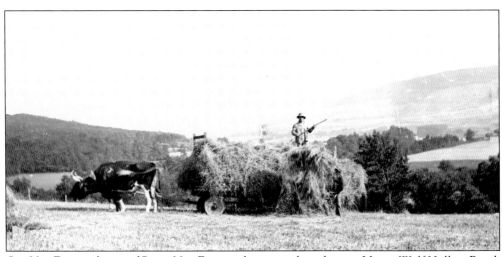

Gus Van Eps, a relative of Percy Van Epps, is shown pitching hay on Upper Wolf Hollow Road. Oxen were often used instead of workhorses on farms.

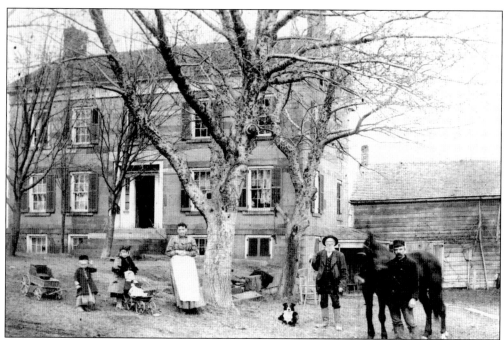

The Dawson Stone House was built in 1842 by John Dawson Jr. Pictured, from left to right, are Nelson L. Dawson, Della L. Hadsell, Mary J. Dawson Hadsell, Henry Dawson, and Charles Dawson.

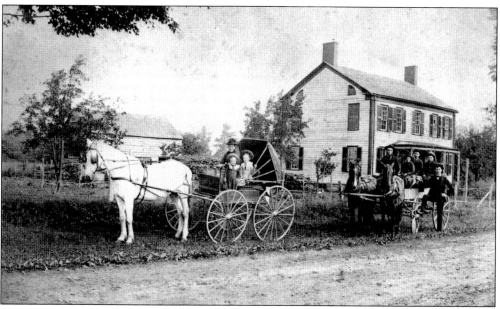

The John Martin Koch house is located at 285 Saratoga Road (Route 50) across from the Trustco Bank. John Martin Koch was a German immigrant. The home was built in the 1880s. In 1910, it became the Wayside Inn. During Prohibition, it was known as the Gay Gull and was a swinging place. It is now endangered because it is in a commercially zoned area. In the first buggy are Anna Marie Koch and son Albert. In the second carriage are John Martin Koch, Ernest, John G., Andrew, and John M. Jr. (standing)

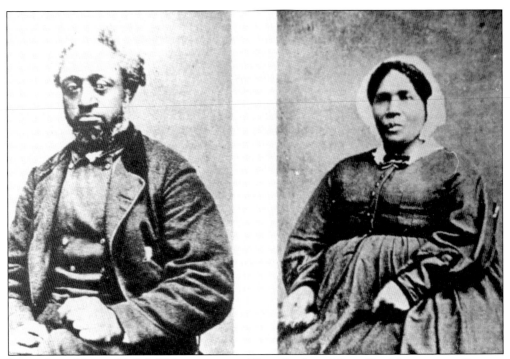

Jeremiah and Mary (Polly) Wilson came to Glenville from Minaville, Montgomery County, sometime between 1830 and 1840. Former slaves, they were freed in 1827, when New York's Emancipation Act took effect. Jeremiah was a teamster, sexton, and grave digger for the First Reformed Church in Glenville. Polly was mother to six children. Both Jeremiah and Polly died in the late 1880s.

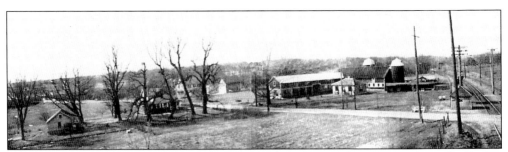

This is a 1930s photograph of Cozydale farm on Glenridge Road. George and Martha Becker Pfaffenbach established the farm on April 1, 1905. On the right are the tracks for the Schenectady-Saratoga trolley. The tracks were later elevated.

John Vander Veer and Harry Moore are wearing top hats in Thomas Patten's barn in West Glenville. The picture was taken c. 1903.

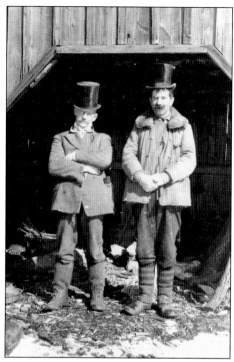

These are the barns of the Matthews farm on Sacandaga Road. The timbers used in its construction came from the old covered Mohawk bridge.

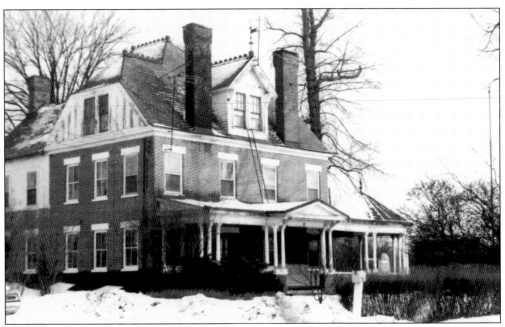

The Yelverton summer house was on the corner of Freeman's Bridge Road and Maple Avenue. The house was originally built by Charles G. Ellis and given to his daughter Mary when she married James Yelverton in 1901. Yelverton was a state senator from 1917 to 1920. He was an organizer and director of the Citizen's Trust Company. This picture was taken in March 1976. The house was demolished in the 1980s.

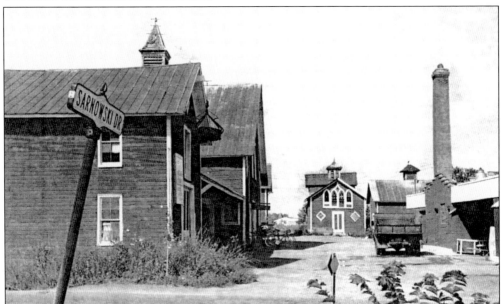

The Yelverton property was sold to Konstanty Sarnowski in 1921. Sarnowski was a leader of the local Polish community in Schenectady. Shown here are the barns of the dairy farm. The weather vane was going to be given to the Schenectady County Historical Society; however, it was stolen before that could happen. For a short time in the 1970s, this area had country stores in the barns.

Barns of the Van Buren farm were located on Van Buren Road. The farm was owned by Fred Van Buren.

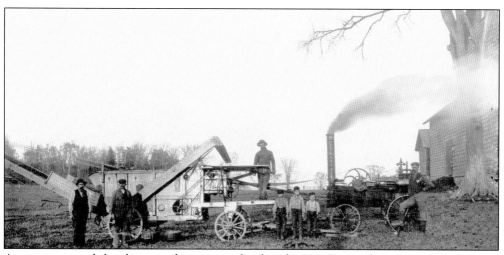

A steam-powered threshing machine was utilized at the Van Derzee farm around 1900 during the grain harvest.

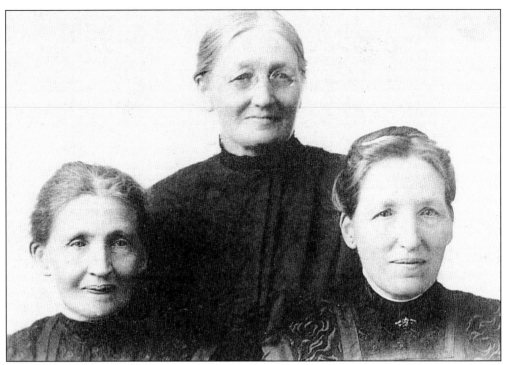

Sisters Caroline Horstman, Hattie Rankin, and Sophia Springer are pictured here at a family get-together.

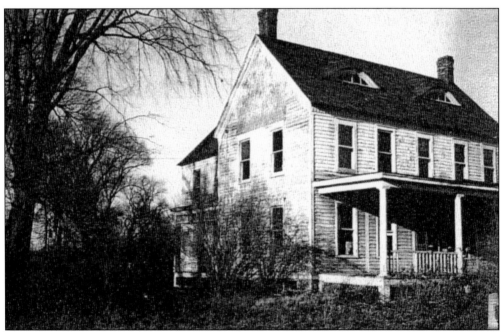

The Horstman homestead was at the corner of Swaggertown Road and Ballston Avenue. This home was demolished in 1970 to make room for a Stewart's convenience store.

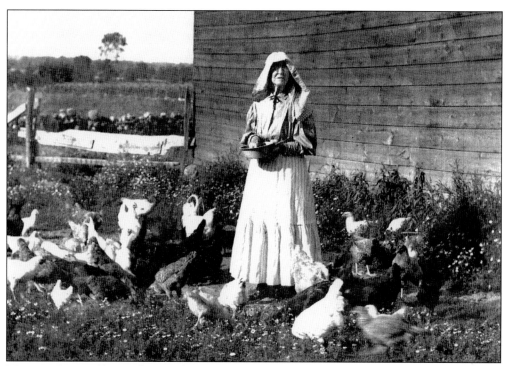

Margaret Jane Teller Weller was born on December 25, 1831, and died in August 1911. The picture was taken on her son's farm on Bolt Road in Center Glenville.

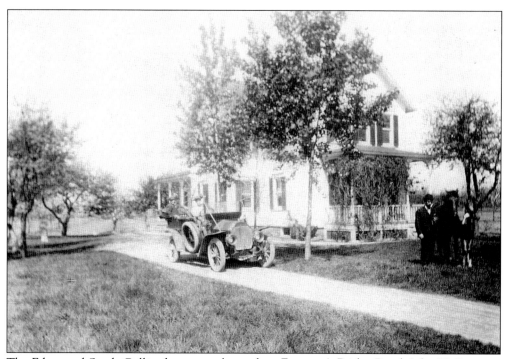

The Edgar and Sarah Collins home was located on Freeman's Bridge Road. John H. Peterson later owned it. The car in the driveway is a 1908 touring car.

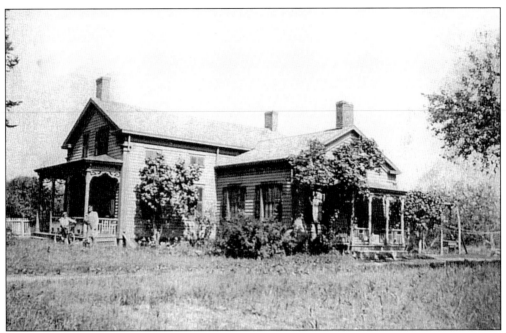

Abram Witbeck once owned the house located at 372 Saratoga Road. The house is still standing but has had extensive renovations.

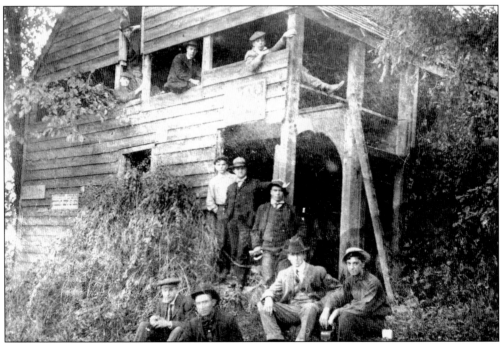

The DeGraff house was built on Sacandaga Road in 1728 and razed in 1918. The Wad-U-Kon-Tu Hiking Club visited it in 1908. Among these young men were Bronson Taylor, Frank King, and Thomas Tighe.

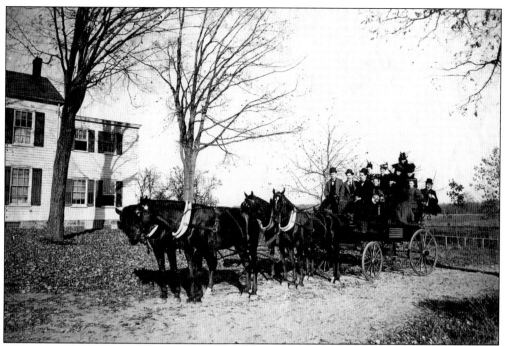

This picture of the Demmings, the Kellers, and others was taken at the McCain farm in Alplaus. Mr. Demming was an engineer at General Electric. Four-horse hitches like this one were owned only by the well-to-do. It was called a tally-ho conveyance and was used before automobiles.

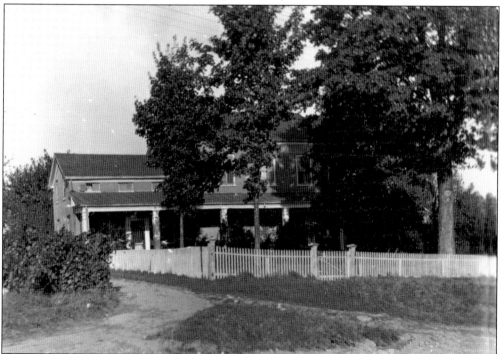

George Conde's home is located in West Glenville Village. The picture was taken at the beginning of the 20th century. Notice the dirt road in the foreground.

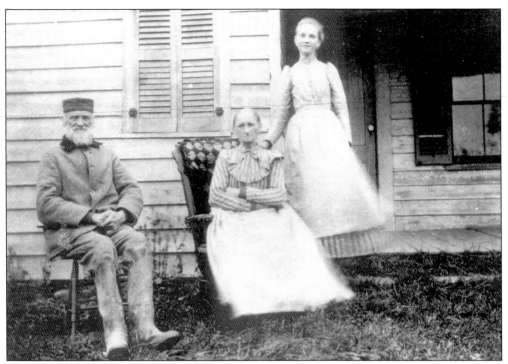

The Oldorf family of northeast Glenville sits in front of their home.

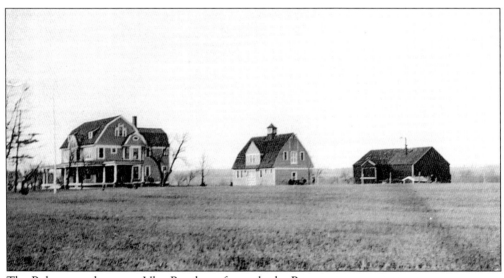

The Buhrmaster home on Vley Road was formerly the Brewster property.

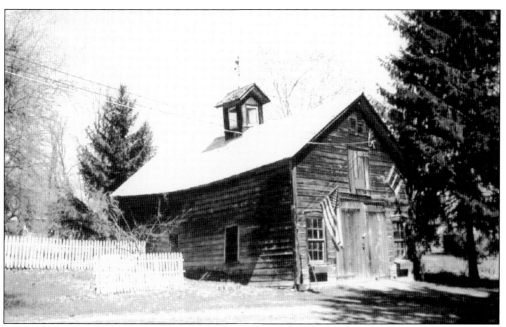

An early barn sits on West Glenville Road. It was once owned by Solomon Hallenbeck and appears on maps dated 1856 and 1866.

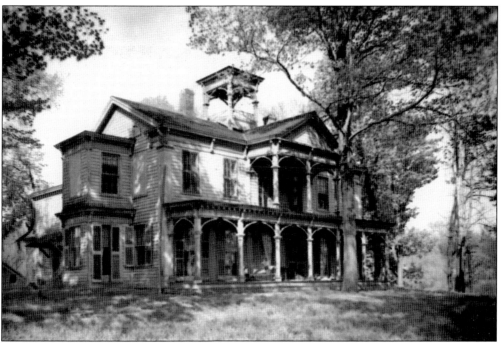

Philip Ryley Toll built Toll Mansion in 1842 on the site of the original Beukendaal Toll farm. From the original farm, Daniel Toll and others departed looking for lost horses on July 18, 1748. American Indians attacked the men, and 19 white men were killed in the Beukendaal Glen just north of Scotia. The building no longer stands.

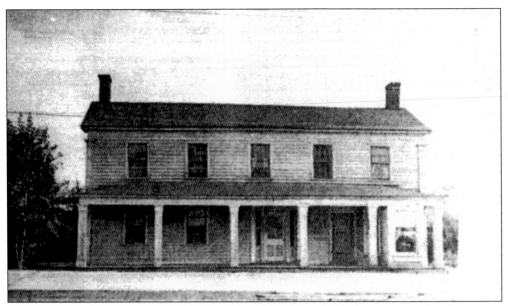

Allen's is located on Route 50. It was a tavern and speakeasy. It has been operated under various names and has had many owners over the years.

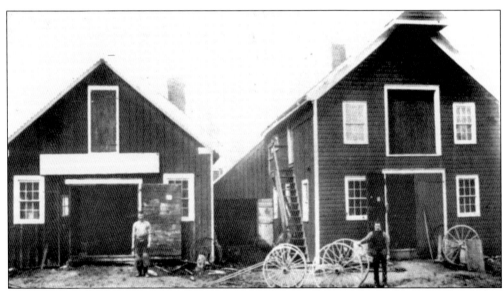

The village blacksmith, George Bull, and wagon maker Matthew Hallenbeck are standing before their shops in West Glenville Village about 1900.

Four

BUSINESSES PAST AND PRESENT

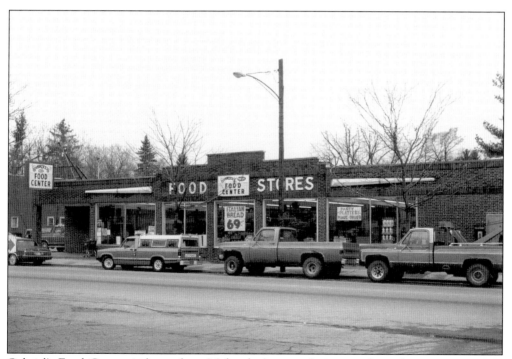

Gabriel's Food Center is located on Mohawk Avenue. It is now the only grocery store on Mohawk Avenue and is heavily used.

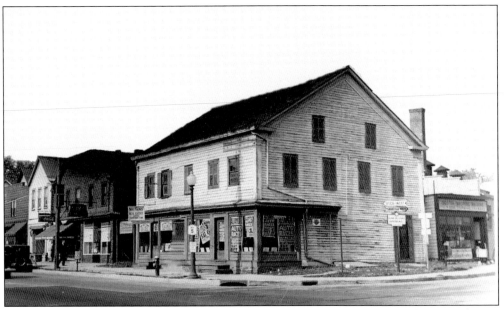

This building was known as the old Cramer Tavern for many years. Later it became Slover's Grocery. The building was standing on the corner of Mohawk Avenue and Ballston Avenue when Scotia was incorporated as a village in 1904. This picture was taken just before the building was razed in 1939.

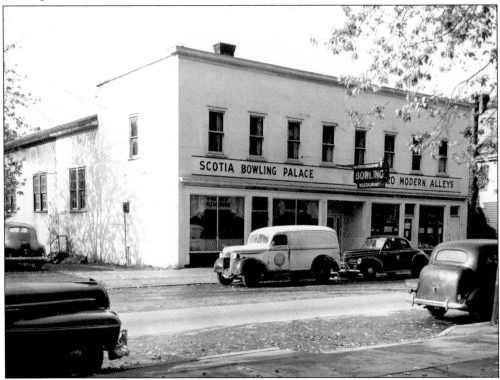

Scotia Lanes, now called Rolling Greens, was a popular place for teens in the 1950s and 1960s. As early as 1912, the building at 115 Mohawk Avenue was a bowling alley and skating rink.

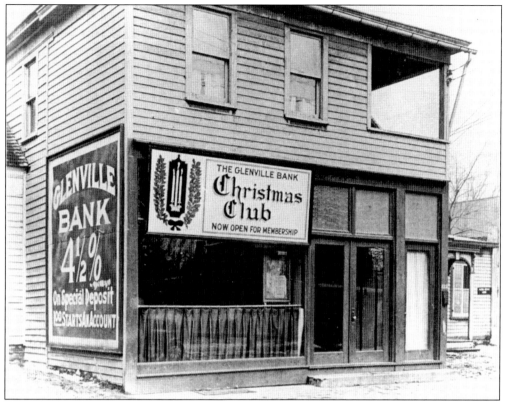

The Glenville Bank began operation on November 19, 1923. The first office was on Mohawk Avenue near where the Dragon Garden Chinese Restaurant is today. The bank grew rapidly and was never in danger of closing during the Depression. In 1953, construction began for a new bank, featuring the first drive-up window in Schenectady County. In 1954, the name of the bank changed to the First National Bank of Scotia.

In addition to auto banking, a sidewalk teller was opened to facilitate speedy transactions on busy days and to accommodate women with baby carriages. Pneumatic tubes were installed to send transactions requiring clerical reference to the main area of the bank. Phyllis Spencer and her son Kenneth take advantage of the drive-up window in this picture taken around 1955.

Healy and Mabee, funeral directors, began their business in the early 1930s at 332 Mohawk Avenue. They later moved to 1 Mohawk Avenue. Eventually, Berning bought out Healy. In 1981, Bekkering bought the business.

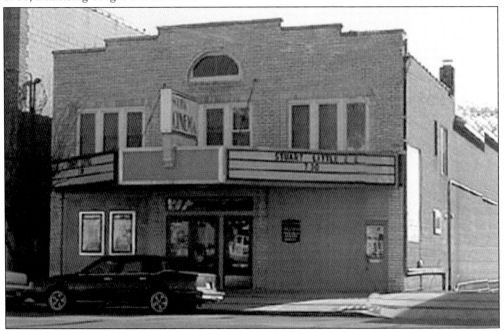

Originally called the Ritz Theater, the Scotia Cinema opened in 1929. When the theater opened, *The Jazz Singer*, the first talkie, was showing and admission was 20¢. Today the theater continues to show movies.

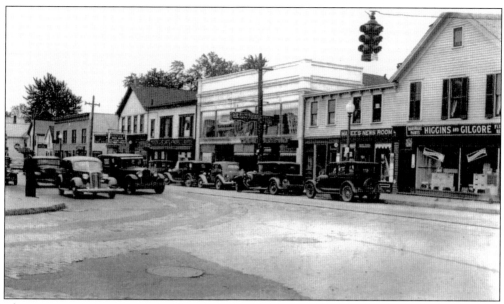

The Higgins and Gilgore hardware store was located at 59 Mohawk Avenue near the corner of Ballston Avenue. The store sold plumbing supplies, fertilizers, stoves, paints, and house furnishings. It operated under this name during the 1930s.

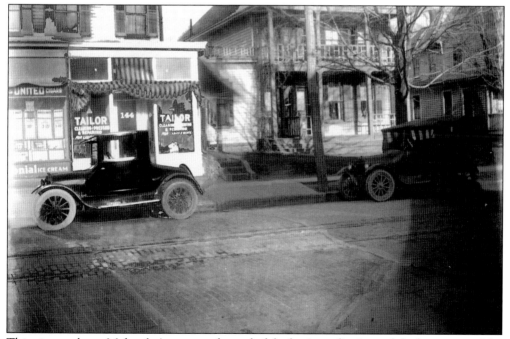

This picture shows Mohawk Avenue at the end of the business district and the beginning of the residential area. The car in front of the tailor shop is a c. 1920 Chevrolet coupe.

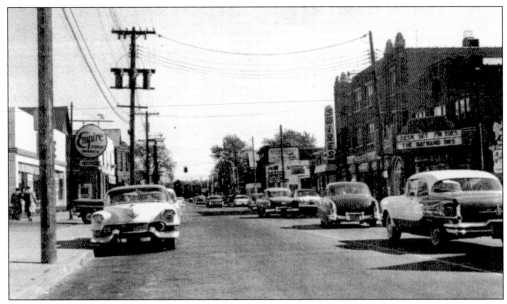

In 1913, Harry Schaffer founded a grocery chain that later became known as Empire Markets. The chain was sold to Grand Union grocery stores in 1958. This picture, taken about 1955, shows both markets on Mohawk Avenue. The Grand Union was torn down, and the space is now occupied by the Family Dollar.

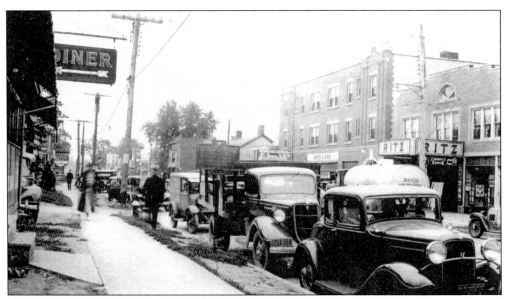

Next door to the Ritz Theater was Mohawk Chevrolet. In 1929, Mohawk Chevrolet was located at 2 Sacandaga Road. The business moved to Mohawk Avenue in 1930. The first manager was William Moore.

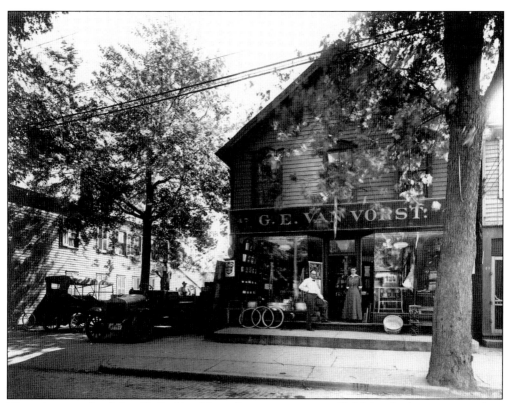

This photograph of the G. E. Van Vorst Company store at 47 Mohawk Avenue was taken around 1915. George E. Van Vorst is standing in the doorway.

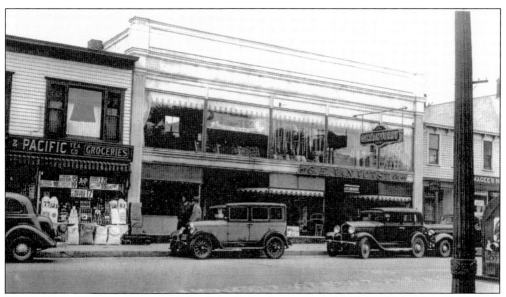

The A&P grocery store is on the left of Van Vorst Company at 47 Mohawk Avenue. Coffee was 17¢ a pound, and soups were two for a quarter. There appear to be apartments on the second floor, for the windows have curtains on them.

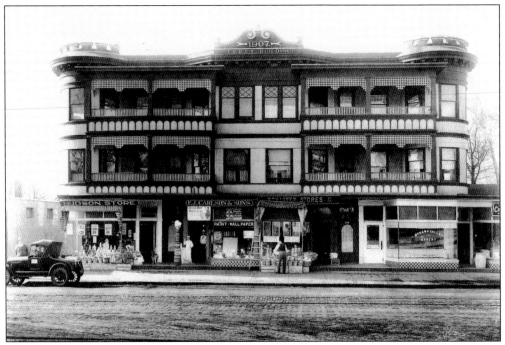

The Teddy Building was built in 1909 at the foot of Sacandaga Road and Mohawk Avenue. It was demolished in the 1990s to make room for a CVS and parking lot. The origin of the name "Teddy Building" is unknown.

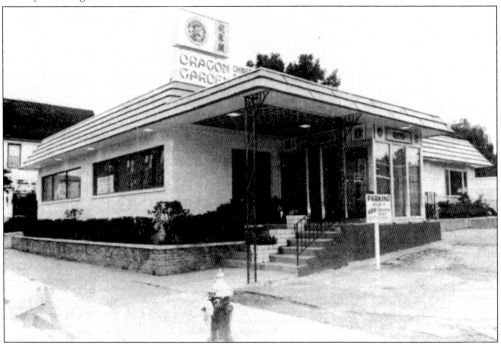

The Dragon Garden Chinese Restaurant was built when the Empire Market, Gibbons Diner, and the Glenville Bank buildings were torn down. The building next door contains a laundry and dry cleaner.

Heitkamp's was a dry goods store on Mohawk Avenue. Long counters held bolts of fabric, and the walls contained shelves of laces and bindings.

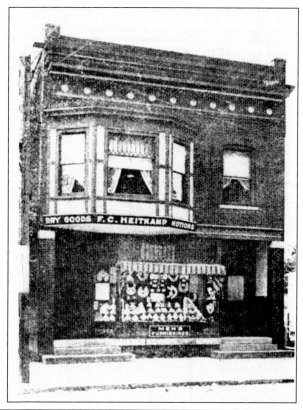

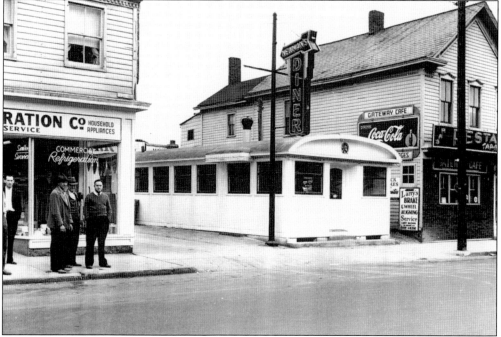

Newman's Diner, at 36 Mohawk Avenue, was a landmark for years until it was torn down in the late 1960s.

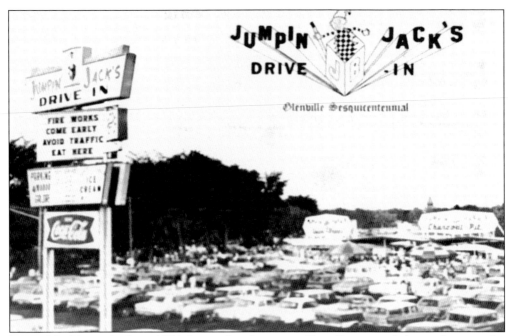

Jumpin' Jack's was built in 1954. It was first known as Twin Freeze, and then it became the Charcoal Pit. The establishment was the area's first local fast-food drive-in. Every year, the restaurant celebrates its initial opening on the last Thursday in March. Jumpin' Jack's also holds the annual Fourth of July fireworks display, which is attended by thousands of people.

This blacksmith's shop was located on Ballston Avenue between Mohawk Avenue and Glen Avenue.

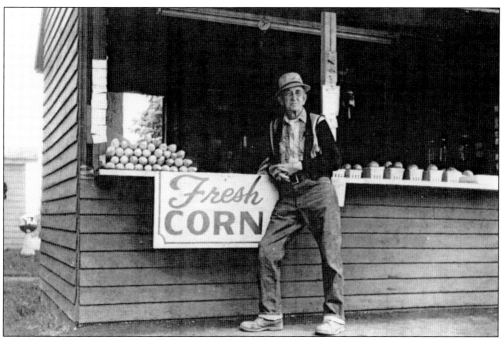

Charles Middleton is standing by his vegetable stand. His farm was located on Swaggertown Road.

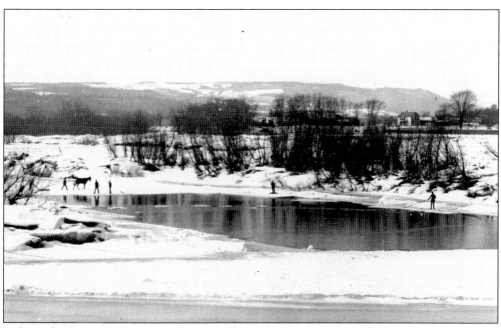

Before refrigeration was commonplace, people would cut ice on the Mohawk River every winter. The ice was stored in sawdust in a large storage shed. James and Charles Collins cut ice on Collins Lake and had an ice business in Scotia.

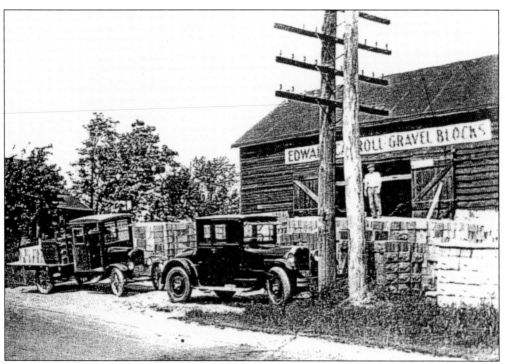

The Edward Carroll Block Company was located on Freeman's Bridge Road near the Schenectady airport. It was there for about 30 years.

The old blacksmith shop owned by Otto Pahl was located at 118 Freeman's Bridge Road. Sometimes horses would fall asleep and fall on the blacksmith while he was shoeing them. Besides keeping the horses and oxen shod, blacksmiths put new runners on sleds.

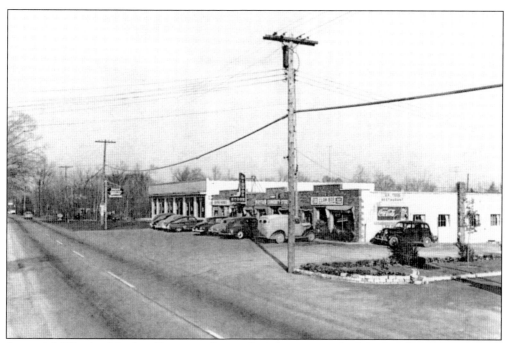

Around 1950, the Mayfair Shopping Center had few stores: the Mayfair Community Store, a clam bar and seafood restaurant, liquor store, and a pharmacy. The shopping center was located at 274–80 Route 50 (Saratoga Road). Today the area is called Hannaford Plaza.

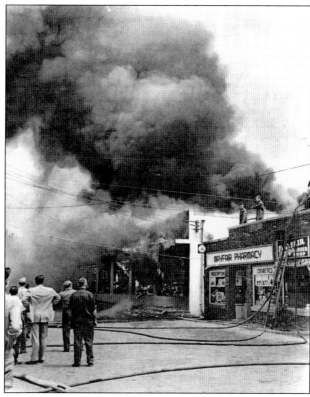

The Mayfair Shopping Center was destroyed by fire about 1978.

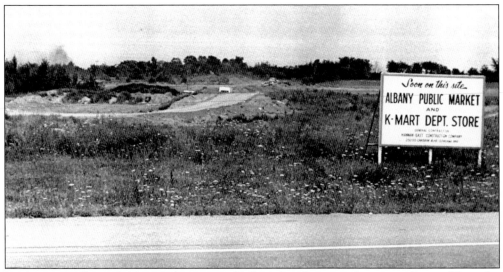

K-Mart and Albany Public Market were added to the shopping district on Route 50 in the early 1970s.

The Robert Stoodley House was located at the southwest corner of Van Buren Road and Route 50. This area was known as Stoodley Corners from 1910 to the late 1940s. The house was sold in 1971 to make way for a gas station.

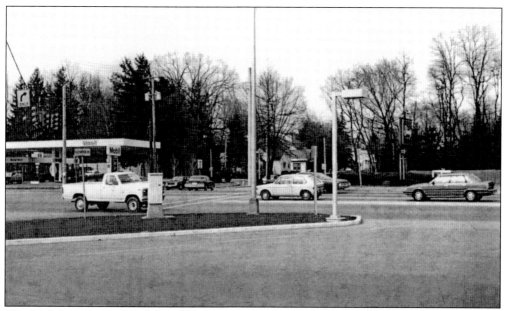

This Mobil station replaced the old gas station that was built on Stoodley's Corners. The Mobil station was erected in 1987.

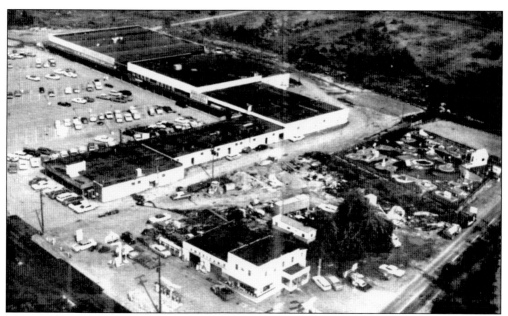

The Mayfair Shopping Center is shown in this aerial view taken in 1969. Today a Hess station has replaced the American gas station, and the Mayfair Mini Golf is gone, a Valvoline Instant Oil Change replacing it.

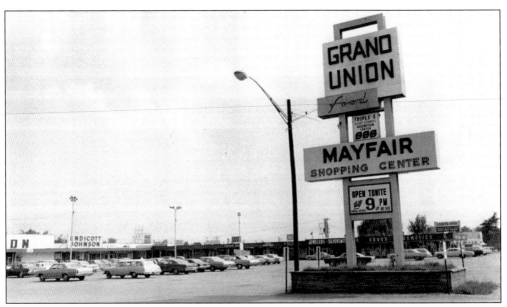

The Grand Union grocery store and Endicott Johnson shoe store were among the first stores in the Mayfair Shopping Center. This shopping center has been renamed Hannaford Plaza.

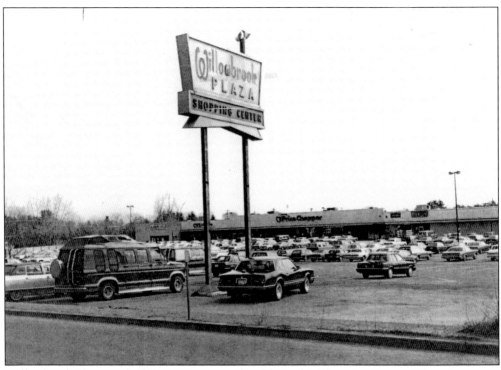

Willowbrook Plaza was built in 1963 next to the old Mayfair Shopping Center. This picture was taken in 1987. The center is now called Price Chopper Plaza.

In June 1972, the two shopping centers contained 40 stores. It is interesting to note there was a trading stamp company where you could redeem books of stamps that you had received on certain purchases.

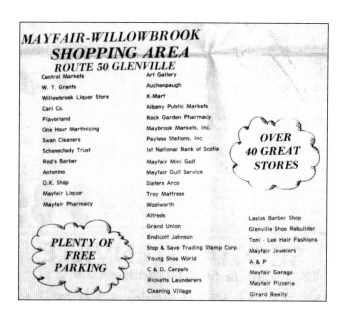

MAYFAIR-WILLOWBROOK SHOPPING AREA
ROUTE 50 GLENVILLE

Central Markets
W. T. Grants
Willowbrook Liquor Store
Cari Co.
Flavorland
One Hour Martinizing
Swan Cleaners
Schenectady Trust
Red's Barber
Antonino
O.K. Shop
Mayfair Liquor
Mayfair Pharmacy

Art Gallery
Auchenpaugh
K-Mart
Albany Public Markets
Rock Garden Pharmacy
Maybrook Markets, Inc.
Payless Stations, Inc.
1st National Bank of Scotia
Mayfair Mini Golf
Mayfair Gulf Service
Slaters Arco
Troy Mattress
Woolworth
Alfreds
Grand Union
Endicott Johnson
Stop & Save Trading Stamp Corp
Young Shoe World
C & D. Carpets
Ricketts Launderers
Cleaning Village

Laslos Barber Shop
Glenville Shoe Rebuilder
Toni - Lee Hair Fashions
Mayfair Jewelers
A & P
Mayfair Garage
Mayfair Pizzeria
Girard Realty

OVER 40 GREAT STORES

PLENTY OF FREE PARKING

Endries Willowbrook Inn was a favorite dining and clambake shop located on Route 50 where Price Chopper Plaza is today. The Endries family purchased the land in 1924 and refurbished the barn to make the inn. A nine-hole golf course was developed in the rear of the property in 1930. Green fees were 50¢ for 18 holes.

This piece of property on Route 50 across from Price Chopper Plaza has an interesting history. It opened as an A&P and changed to Boardman's, Fay's Drugs, the Eckerd drugstore, and a dollar store. Today it is closed.

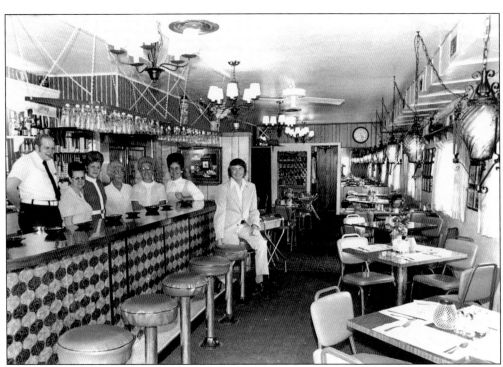

Auchenpaugh's was a German restaurant located at the Mayfair Shopping Center. It was in business for about 25 years from the 1950s through the 1970s.

Mrs. Froelich is tending bar at Froelich's Inn, located at 507 Saratoga Road (Route 50).

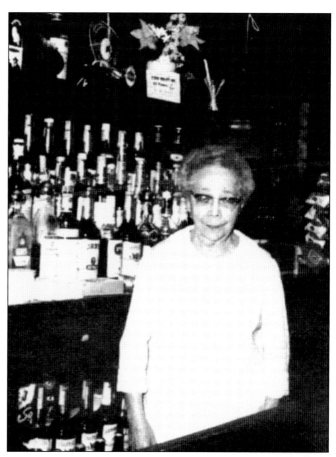

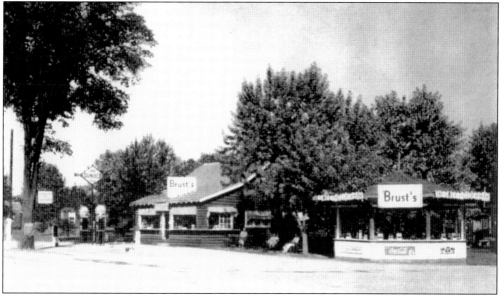

Brust's was a business in High Mills on Route 50. There was a refreshment stand, gas station, convenience store, and cabins. The property now belongs to Fogg's Automotive.

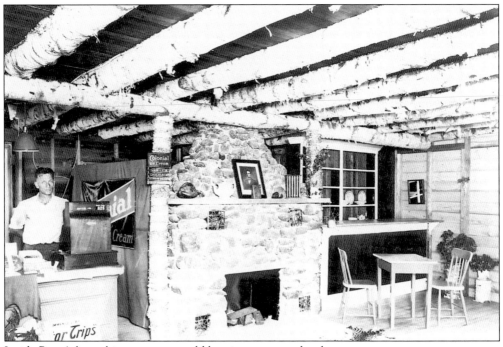
Inside Brust's log cabin store you could buy ice cream and sodas.

The Vedder Tavern, located on Amsterdam Road (Route 5), was built in 1709 and is one of the oldest buildings in the area. The walls are two feet thick, and the floors are of pine plank. In the cellar there were slave quarters. The tavern was well known in the days of river travel.

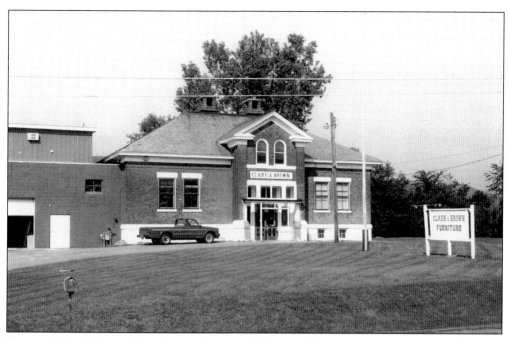

Rectors School is located on Amsterdam Road (Route 5). The school was formed in 1815, but the date of the building is unknown. In 1843, there were 85 students registered. The school closed in 1949. Clark & Brown Furniture Store opened soon after.

This building served as a cooper shop. It was located on Swaggertown Road south of Bolt Road. The building is noted on the 1866 Beers map. Coopers made buckets, drinking mugs, wooden tankards, milk pails called "piggins," and barrels. Cooper shops were found on every road and in every hamlet.

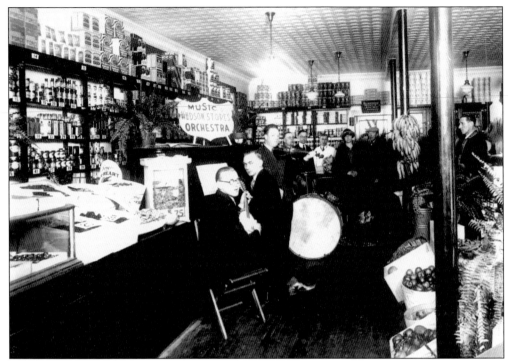

Hudson Food Market was a general store on the corner of Vley Road and Fifth Street. It is interesting to note that the store must have sponsored a musical group. Note the bananas hanging, the apples in open bins, and the wide variety of merchandise displayed on the counters and walls.

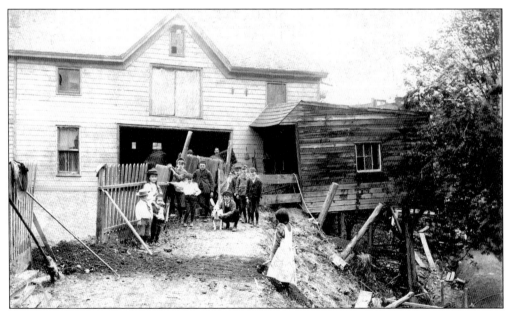

DeForest livery stables are shown in this picture. In the days before cars, it was possible to rent horses and carriages.

Five

GATHERING PLACES

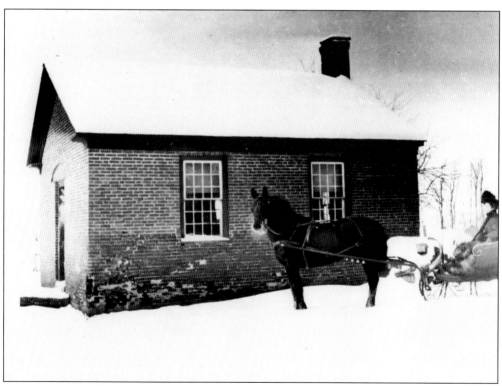

Greens Corners School is located on Potter Road. It is the oldest one-room school in the town. Grades one through eight attended. The students carried water from a farm on the corner. The school is now a museum.

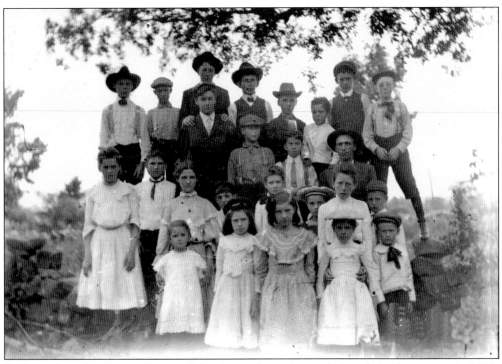

Students from the Greens Corners School pose for a picture during their class picnic in 1912. Ruth Alexander was the teacher.

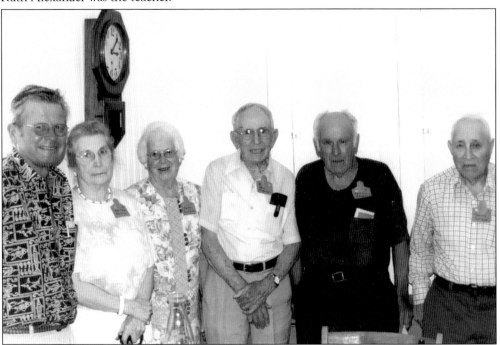

Alumni from the Greens Corners School held a reunion in 2003. Shown here, from left to right, are Theodore Dick, Marcella Marvin, Marjorie Haushalter, Joe Kmonk, Anthony Kmonk, and Howard Tatlock.

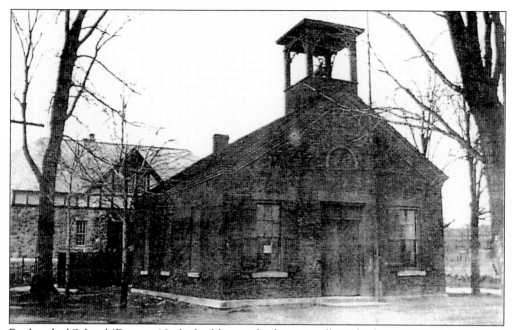

Beukendaal School (District 10, the building in the foreground) was built in 1823 and demolished in 1915. The cobblestone building in the background was built in 1914. This picture is rare since it shows both buildings. This school last operated in 1953. The Scotia-Glenville School System now uses the building as a bus garage.

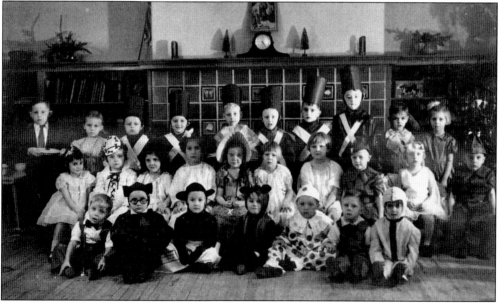

Sacandaga School kindergarteners pose in 1935. The teacher was Miss Smith, later Mrs. McBride. In the first row, the third child from the left is Janene DeGroat. In the second row, from left to right, are Virginia Van'dwater (sic), Phyllis Bornt, Rose Tebbano, Ruth Graptin, Hannah Marshall, Maddy Crandal, unidentified, unidentified, unidentified, and Don Wayand. In the third row, from left to right, are Warren Patterson, Sue Moffett, Byron Felter, unidentified, Steve Simpkins, Jim Lampard, unidentified, Dick Butch, Jack Carbin, and unidentified.

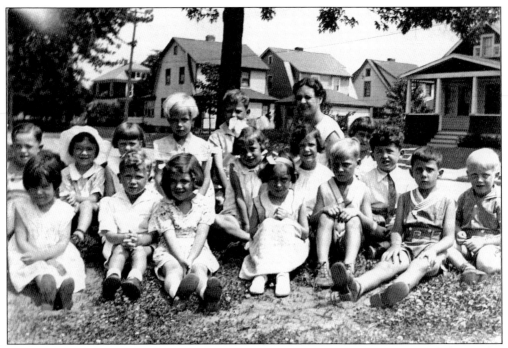

Lincoln School primary students are enjoying the sunny day. Shown here, from left to right, are the following: (first row) unidentified, Ray Abare, Marjorie Carman, Hilda Ippoliti, Don Quick, Jim Girvin, and unidentified; (second row) Tom Fahey, Claire Lee, unidentified, Robin Dunham, Joan Rehemeyer, unidentified, and Norman Noyes; (third row) Phillip Watrobski, teacher Miss Hennesey, and unidentified.

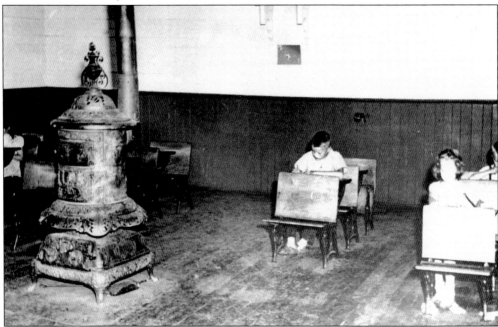

The interior of the Washout Road School is shown as it looked in 1915. Notice the large wood stove on the left.

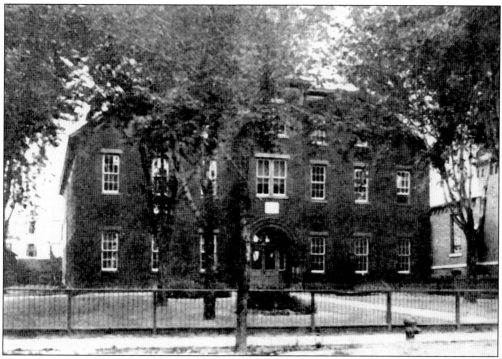

The Mohawk School on Mohawk Avenue in Scotia later became the Colonial ice cream plant. Today that site is a parking lot. The Mohawk School moved to Ten Broeck Street and is now condominiums.

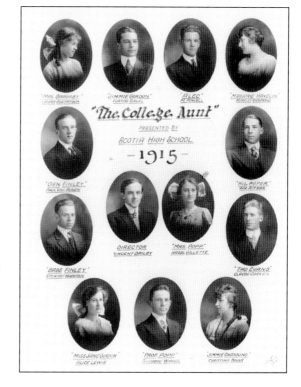

Scotia High School presented the play *The College Aunt* in 1915. Pictured here are Laura Gustafson, Curtiss Siegel, M. Powell, Aurelia Richmond, William Ritzer, Claude Carver, Christina Bousa, Theodore Warner, Alice Lewis, Stewart Hoeston, Paul Van Auken. In the center are Vincent Daily and Hazel Gillette.

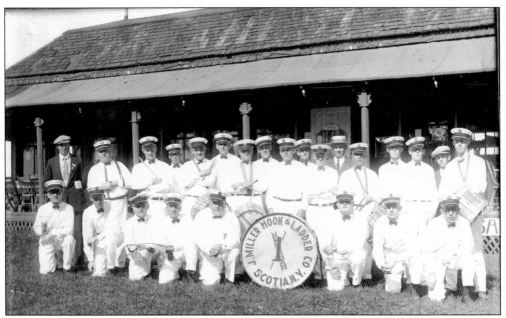

On August 22, 1910, the John Miller Hook and Ladder Company was organized as the second branch of the fire department of the village of Scotia. The John Miller Hook and Ladder Company had a band. William H. Wayand, second from the right in the first row, was the first fire chief.

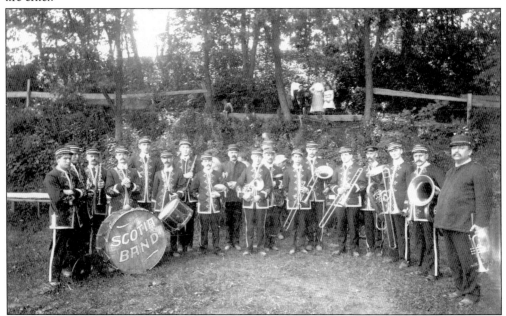

Local bands were very popular at the beginning of the 20th century. The Scotia Band formed in 1897 and ceased performing in 1905. Their picture was taken at the site of Collins Park. From left to right are Ensign Reynolds, George A. Van Vorst, Henry Lealand, George Atwell, Frank Hutchinson, Lewis Bowers, William Ming, George Gayer, Joseph Mallory, Andrew Lansing, Daniel Smith, John Snare, George E. Van Vorst, Hugh Frost, Edward Hutchinson, Lester Lansing, Lewellyn Ford, and Professor Revett (leader).

Collins Lake was originally called Sanders Lake because it was on the Theodore Sanders property. When James Collins purchased the land and lake in 1842, it became known as Collins Lake. The lake is glacial in nature.

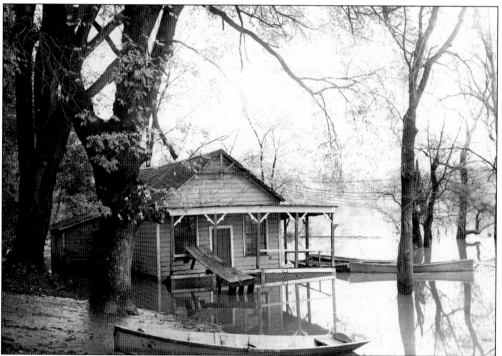

At Collins Park lake house, you could rent a flat-bottomed boat for 10¢ an hour. You could pick the pond lilies while boating, but upon return of the boat you would be charged 2¢ for each flower. This picture was taken around 1900 during a flood.

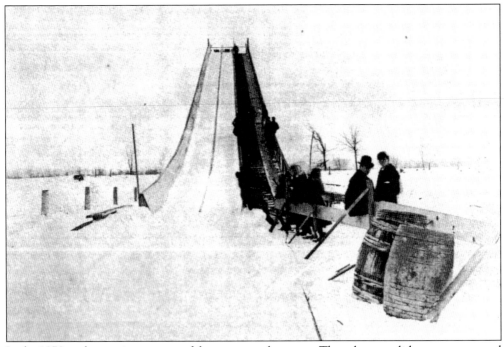

In the 1870s, tobogganing was one of the most popular sports. The toboggan slide was constructed near Schonowe Avenue in Collins Park.

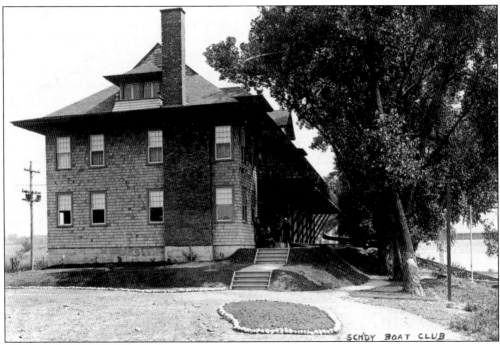

The Schenectady Boat Club formed in 1909. They built this rustic building on the Scotia shore of the Mohawk River near the end of Washington Avenue in 1911. It was destroyed by fire in September 1941 several years after the club's dissolution.

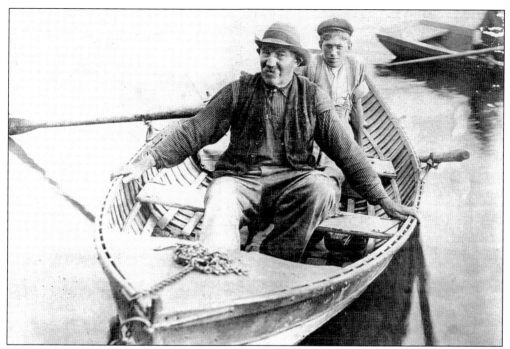

William Reynolds and his grandson Herman E. Reynolds seem to be enjoying the afternoon canoeing on the Mohawk River. In the early 1900s, people often used the river for recreation.

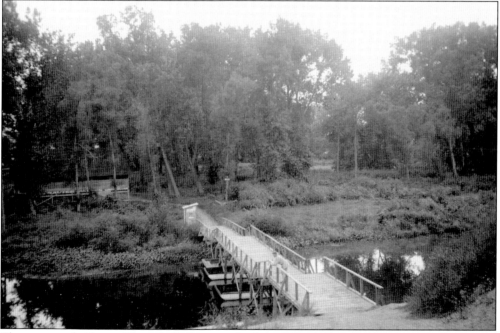

The pontoon bridge to Glenotia Park was at the foot of South Ballston Avenue. The bridge was taken in every fall. Glenotia Park was constructed after Collins Park closed in 1905. The dance pavilion and other amusements were moved here.

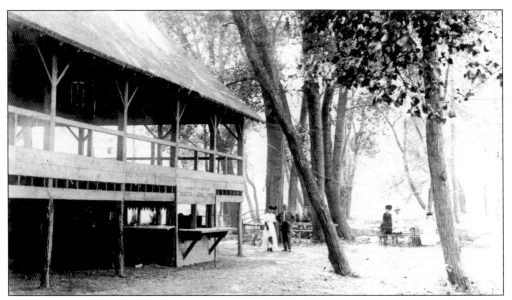

Glenotia Park was on a river island. The island was leased from the Sanders family. There were areas for sports and picnics, and dances were held in the two-story pavilion. The park closed in 1931–1932. Cars were more in use, and the need for the park diminished. Cars could not drive over the pontoon bridge.

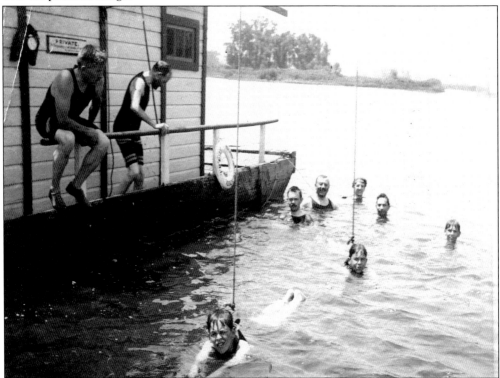

The Mohawk Swimming School, started by Werner Geweck, ran from 1915 to 1930. It cost 5¢ for park admission and 10¢ extra for bathing. Ropes were attached to the swimmers in this beginners' class.

Freedom Park was founded in 1976. It was the dream of Dennis Madden, the mayor of Scotia. The Bicentennial Commission was formed to represent Schenectady County as plans were made for the 200th anniversary of our country. Citizens and civic organizations built the park and planned the celebration.

Scotia was incorporated as a village in 1904. Fifty years later, the town celebrated its golden jubilee.

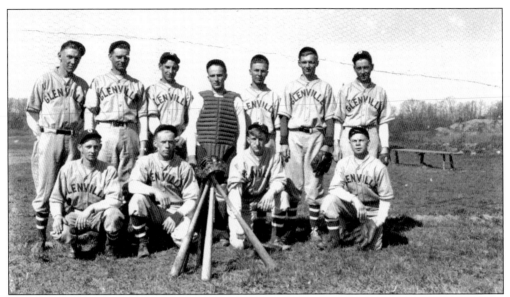

Eleven members of the West Glenville baseball team pose with equipment and uniforms. Shown here are, from left to right, the following: (first row) Chet Prench, Chuck Krutz, Harry Collins, and Bill Clapper; (second row) Chuck Kissin, Charlie Heddin, Ken Hartman, Duane Clark, Buster Clapper, Francis Conde, and Pete Pierson.

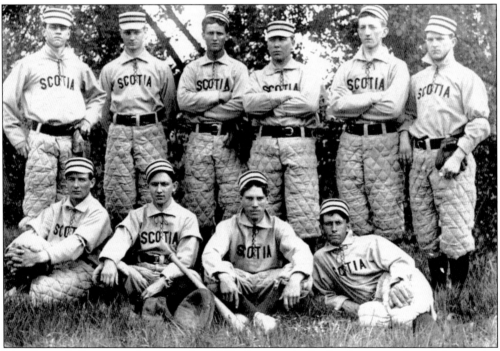

The Scotia ball team is shown in this 1900 photograph. In the front row, from left to right, are unidentified, Edgar Eagnor, Arthur Jackson, and Edward Beller. In the back row are an unidentified player, Martin Ferguson, Frank Berning, Richard Van Heysen, Ralph Hoyt, and Alvin Spitzer.

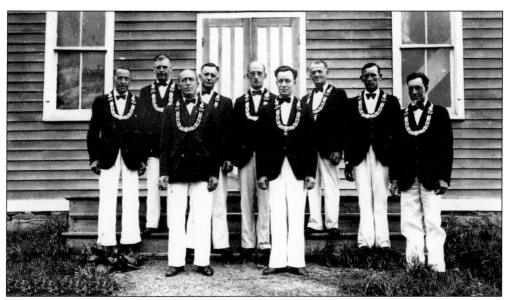

These nine men belonged to the Order of the Odd Fellows of West Glenville. They are all wearing ceremonial Odd Fellows chains around their necks.

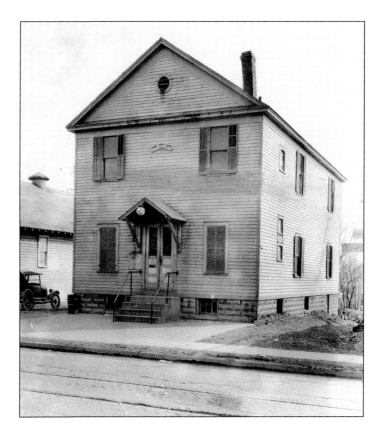

Odd Fellows Hall was located on 251 Mohawk Avenue in Scotia.

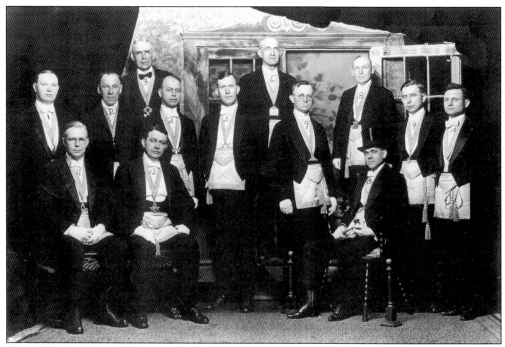

Men of the Beukendaal Masonic Lodge No. 915 are shown here. Each man has a number that identifies him: Bob Zollner (1), John Kemp (2), John Miller (3), Wylie Heter (4), C. O. Daily (5), Jacob Weller (6), John Henry Buhrmaster (7), Arnie Ffaste (8), James Hemstreet (9), Ernie Lehman (10), P.E. Rose (11), J. Mason Hotchkiss (12), and Alfred Bowman (13).

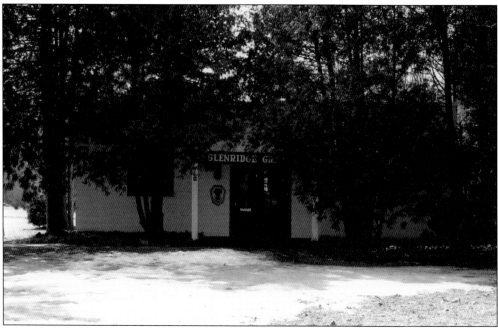

Glenridge Grange No. 1544 was organized in 1935 and is located on Pashley Road in Glenville. In 1948, the present building was constructed on land donated by Thomas Pashley. Only a handful of members remain.

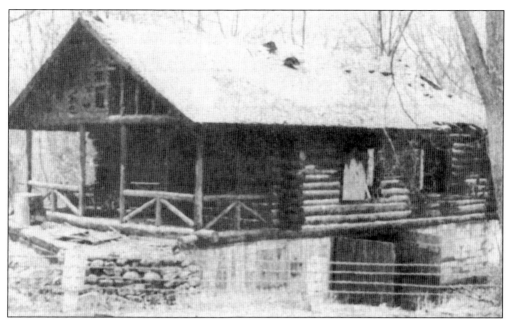

The explorer post was built in High Mills in the 1950s. It is a log cabin that overlooks the Alplaus Creek.

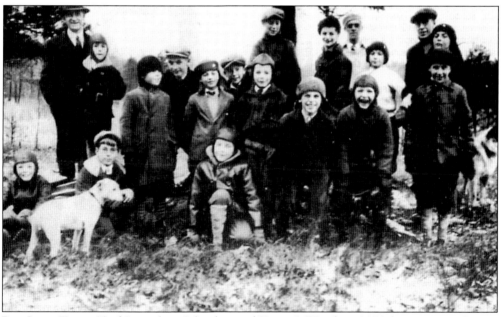

Boy Scout Troop 65 of Sacandaga School visited Kinum's Woods in 1932 for an outing. Sitting at the left is Richard Ridings. Kneeling in front are, from left to right, Robert Buechner and James Muddle. Also included in the photograph are D. Emerson Hitchcock, Melvin Barney, Earl Forbes, Smith G. Cook, Leland Teller Jr., John Steadwell, H. H. Buechner (scout committeeman), Gordon Mercer, Robert Scott, Douglas Bainbridge, Douglas Adams, Harlan Barney (scoutmaster), and D. M. Hitchcock (scout leader).

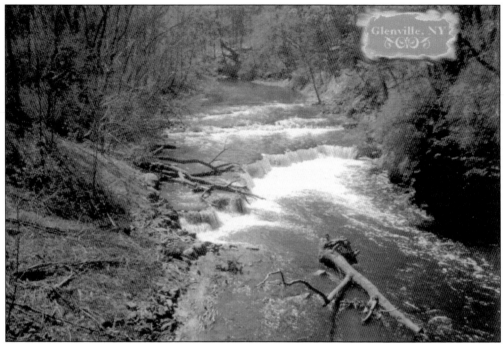

There are small rapids, or white water, in the Alplaus Creek, which runs behind the explorer post. High Mills was the site of several mills in the 19th century. A sawmill was located nearby.

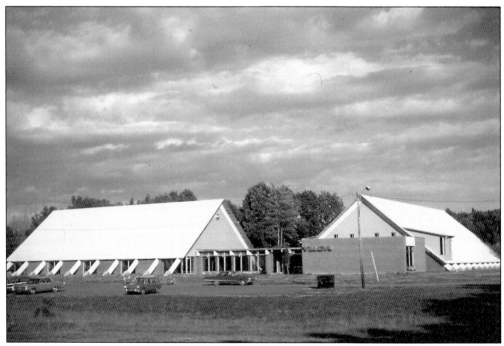

The Greater Glenville YMCA, located on Droms Road, was formerly known as the Parkside YMCA. It was built in 1970 and, to this day, provides recreational activities for residents. It is a branch of the Capital District YMCA. This picture was taken on July 4, 1972.

St. Joseph's Catholic Church was organized at the request of Catholics in Scotia. Rev. Thomas Judge purchased nine lots on First Street. The parish hall was built first, and mass was celebrated there on Easter Sunday in 1909. The rectory was completed in 1913. The church was the last part to be constructed. The first mass was celebrated in the church on December 18, 1927.

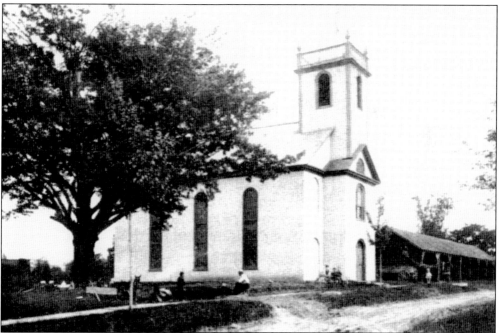

The First Reformed Church in Scotia was built between 1817 and 1822. It was remodeled in 1881, and the bell was added in 1893. The photograph shows the church at this time. A new church of brick was built in 1903 but destroyed by fire in 1943. From 1945 to 1952, the congregation met in a remodeled carriage house that stood on the grounds.

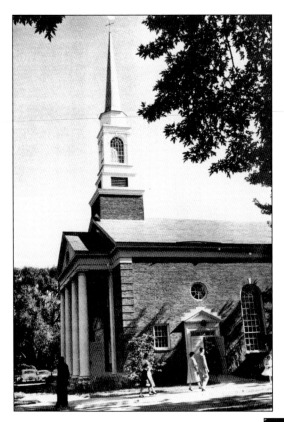

In 1951, ground was broken for the new First Reformed Church in Scotia. The following spring, the church was dedicated. The Dutch Fair began as a fundraiser to help with construction costs for the new church. The fair is now an annual event held in September.

The Scotia Methodist Church had a chapel that was built in 1903. The present church, located at North Ten Broeck and Catherine Streets, had its groundbreaking ceremony in 1922, and in 1923 the cornerstone was laid. Church school children contributed their pennies to purchase the cornerstone.

In December 1976, after 34 years of neglect, the steeple of the First Baptist Church was repaired while the rest of the church was renovated.

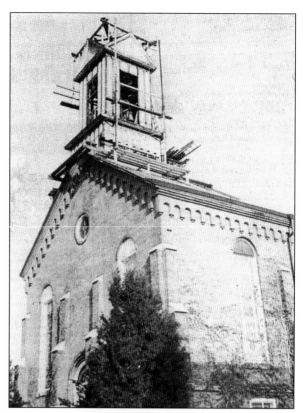

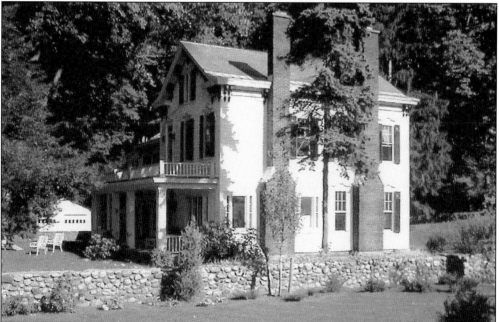

The Viele house was built in the 1800s and has since been restored. The house has double chimneys, and the grounds that surround it are beautiful. Riverstone Manor, a banquet facility, was built on the property.

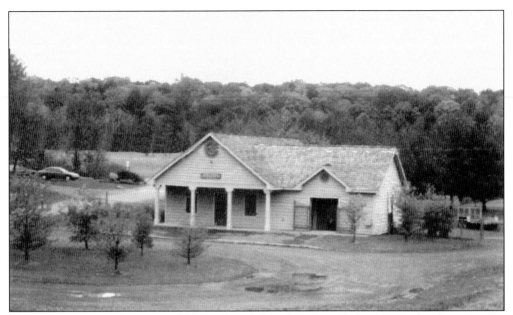

The town of Glenville purchased the land for Indian Meadows Park in 1963. A referendum for using federal funds for the parkland was presented to the voters. It won by a narrow margin, but 5,000 voting-age residents did not register to vote.

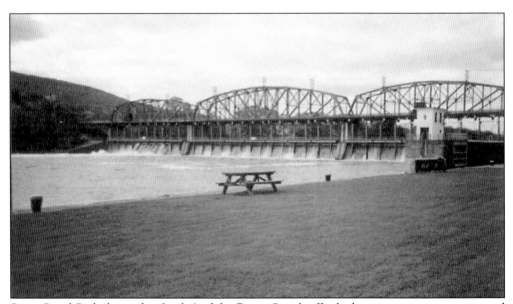

State Canal Park, located at Lock 9 of the Barge Canal, affords the opportunity to picnic and watch boats traveling through the lock.

Six

PROUD TO SERVE

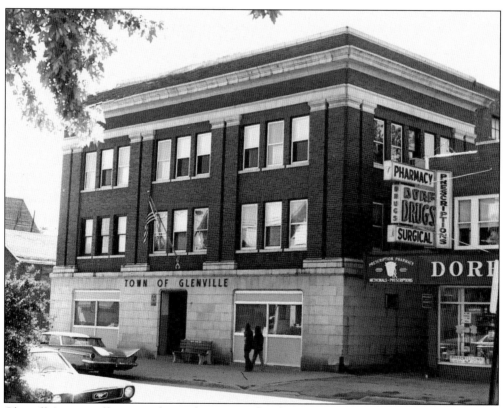

Glenville's town offices were located at 127 Mohawk Avenue. Beukendaal Lodge constructed the building in 1925 as a Masonic hall. Town meetings began at this location in 1926, having been transferred from village hall. The town board purchased the building in 1956.

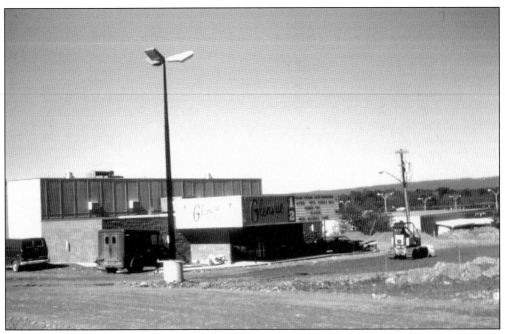

The Glenvue Theater, on Glenridge Road, is shown as it appeared in 1973, the year it was built. *Sleuth*, with Michael Caine, and *Baxter*, with Patricia Neal, were the movies that were playing at the time. The theater was rebuilt in 1984 and became the new home of the Glenville town government.

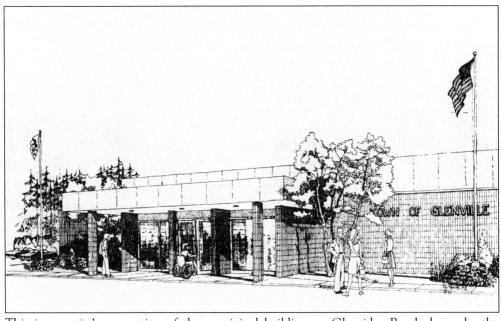

This is an artist's conception of the municipal building on Glenridge Road, drawn by the architectural firm of Cullen Associates. The building was opened in 1985.

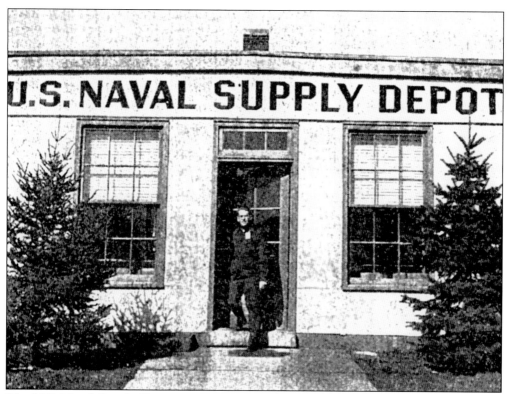

The U.S. Naval Supply Depot was commissioned in 1943 at the site previously known as Kinnum's Woods. Shown here is Louis Kinnum, grandson of the former owner.

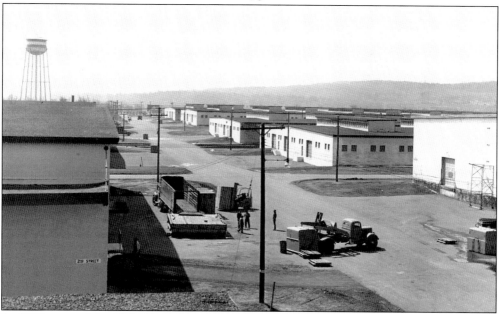

In 1967, part of the U.S. Naval Supply Depot property was purchased by the Schenectady Industrial Council and was transformed into Corporation Park. Today the land is home to numerous businesses. Its convenient location near thruway exit 26 makes shipping easy.

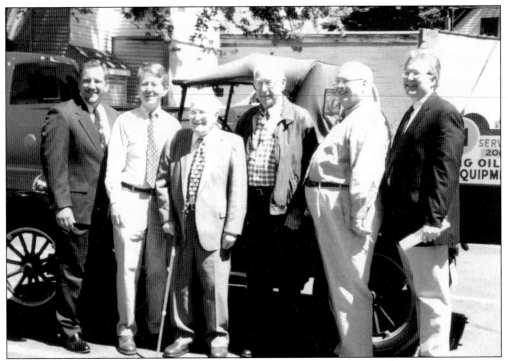

The previous mayors of Scotia took part in the town's centennial parade on June 12, 2004. Shown here, from left to right, are Jim Denney (1994–1998), Will Seyse (1990–1994), Al Lucier (1990), John Ryan (1986), Mike McLaughlin (1998), and Dennis Madden (1986–1990).

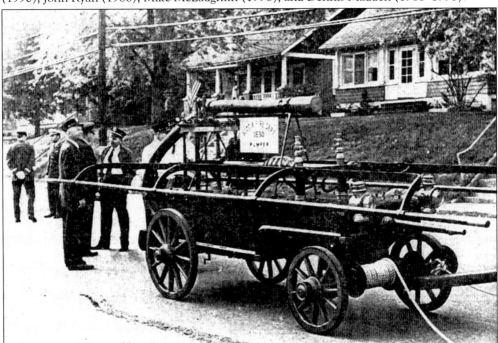

W. E. Worth and Son of Albany built the 1830 pumper, which is owned by the Scotia Fire Department. It is known as Old Neptune No. 4 and is still used in parades today.

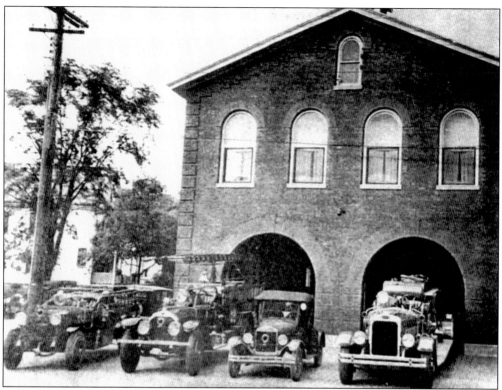

The second Scotia firehouse, which is still in use today, was built in 1908 on the same site as the old one. The Neptune Engine Company was formed in 1873 after a series of disastrous fires struck the town. Established under the leadership of William L. Warren, it is the oldest fire company in the town of Glenville.

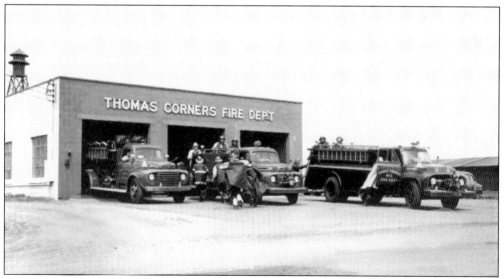

Thomas Corners Fire Department was established in 1949. Robert Hollenbeck, the owner of Pedrick's Florist, was influential in establishing a fire company of volunteers. Leon La France was the first chief.

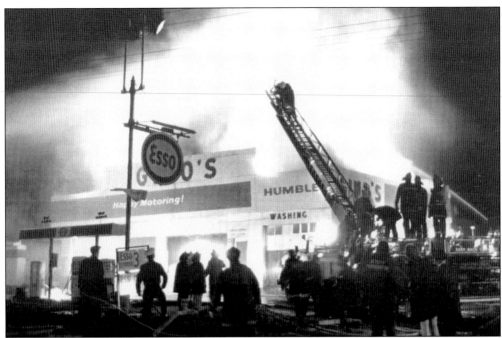

The Thomas Corners Fire Department fights a fire at Gino's gas station on February 23, 1970.

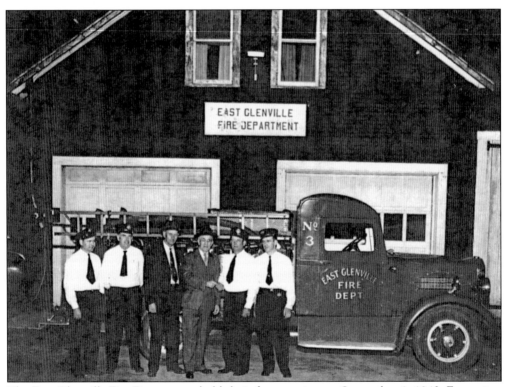

The East Glenville Fire Department held their first meeting on September 1, 1943. Formation of the district was approved on December 14, 1944.

In 1971, the Glenville Town Board began the development of a full-time police department. From 1971 until 1976, the force grew to seven members. It moved into the town hall in 1976. Pictured here is the first chief, William Przybylik, who was appointed in 1976.

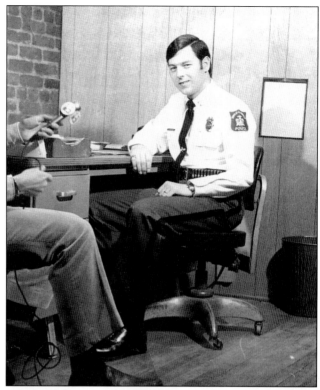

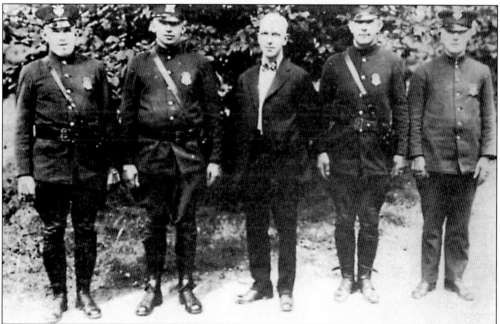

Included in this c. 1925 view of the Scotia police are Howard Smith, Floyd J. Parks (commissioner), Phil Kline, and Edward Consaul. Floyd Parks was the first officer on the staff and was appointed chief in 1920. From 1917 to 1920, he was the only officer serving 24 hours a day 7 days a week. He had one day off a month.

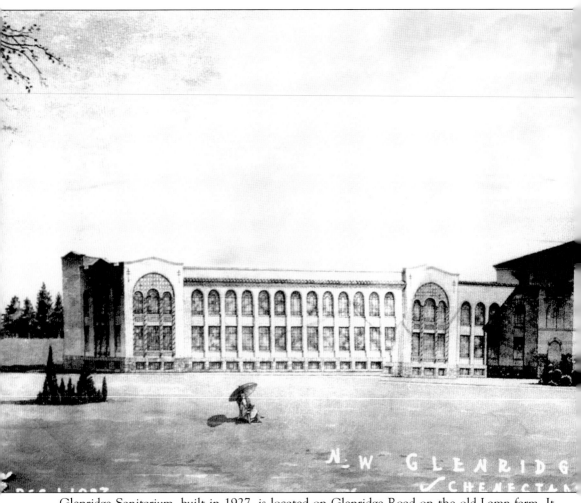

Glenridge Sanitarium, built in 1927, is located on Glenridge Road on the old Lamp farm. It

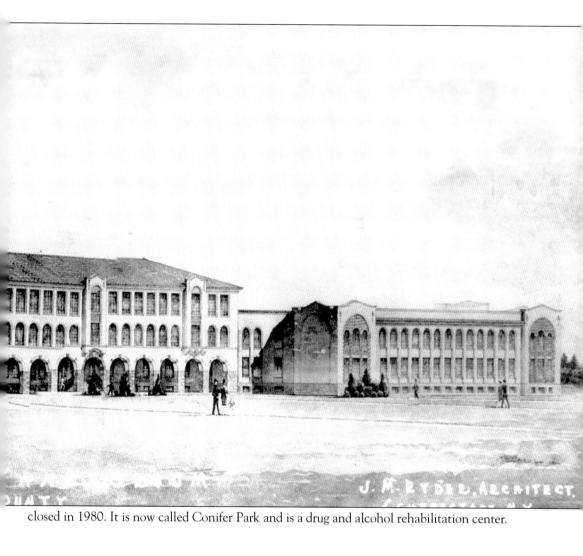

closed in 1980. It is now called Conifer Park and is a drug and alcohol rehabilitation center.

This is a picture of the first building that was the Glenridge Sanitarium. Originally built as a tuberculosis hospital in 1912, the sanitarium was used until 1927.

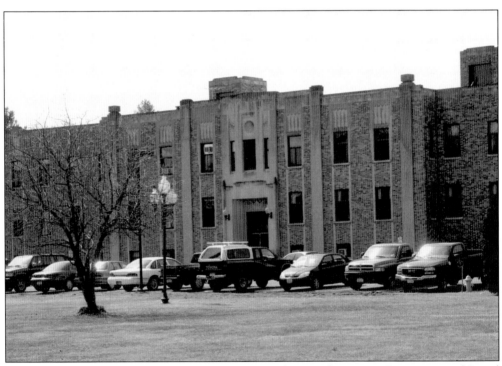

Glendale Home, a nursing home operated by the Schenectady County Department of Social Services, is located on Hetcheltown Road. It began operation in 1936 with 359 patients. In 1960, a second building was added to the complex. The hill behind the home is a well-known winter sledding spot for Glenville children.

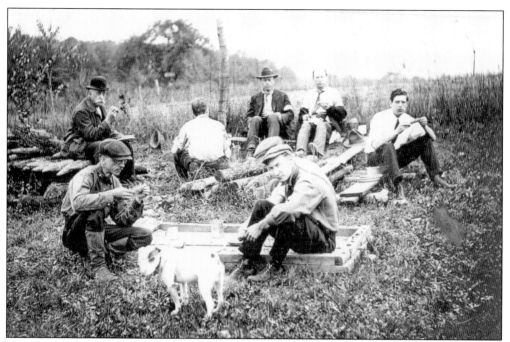

The Scotia Home Guard was organized during World War I. They are pictured here encamped on Spring Road in October 1917.

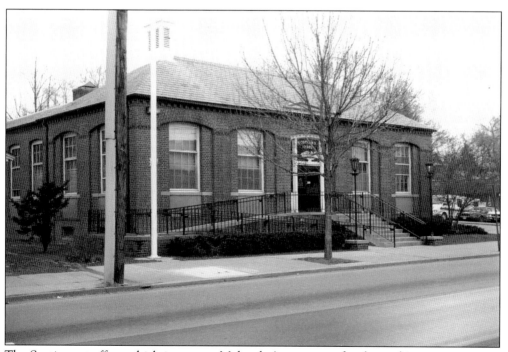

The Scotia post office, which is now on Mohawk Avenue, was first located in a grocery store. This building was constructed in 1940, and Jasper Hallenbeck was postmaster.

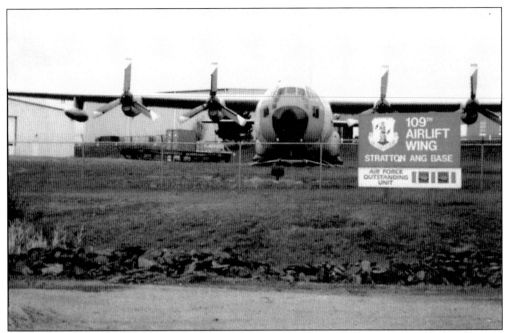

Stratton Air National Guard was named for Sam Stratton, who served as mayor of Schenectady and later as a U.S. congressman. The 109th Airlift Wing was formed in 1948 at the Schenectady County Airport. The first aircraft they used were F-47 Thunderbolts. Today the 109th supports the National Science Foundation's research stations in Greenland and Antarctica. They received national attention in 1999 when they performed a rescue mission in Antarctica during the Antarctic winter.

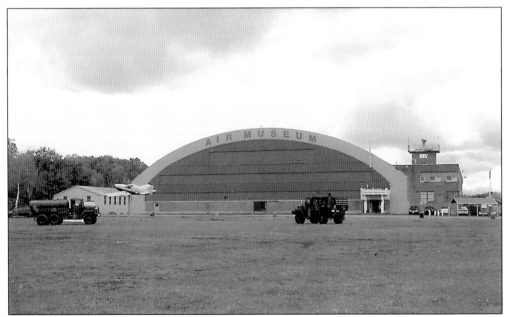

The Empire State Aerosciences Museum was founded in 1984 to preserve New York State's aviation history through a collection of aircraft and exhibits. They often have air shows.

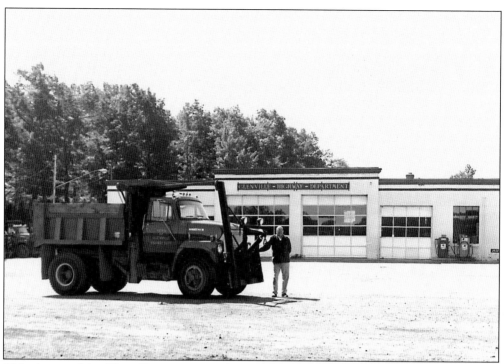

This picture of the Glenville town garage, located at 375 Vley Road, was taken in 1972.

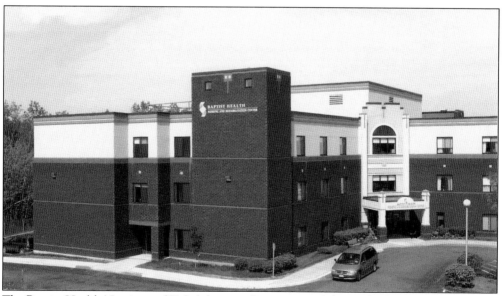

The Baptist Health Nursing and Rehabilitation Center opened the week of November 9, 1977.

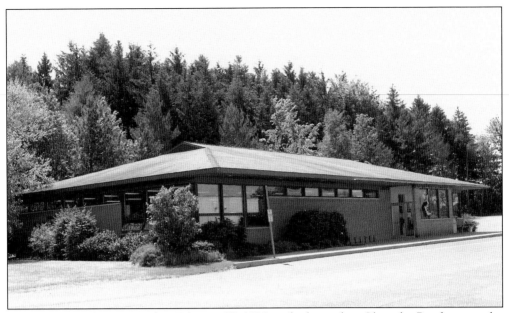

The Glenville Library opened on February 27, 1990, and is located on Glenridge Road next to the Glenville municipal center. It is a branch of the Schenectady County Public Library System.

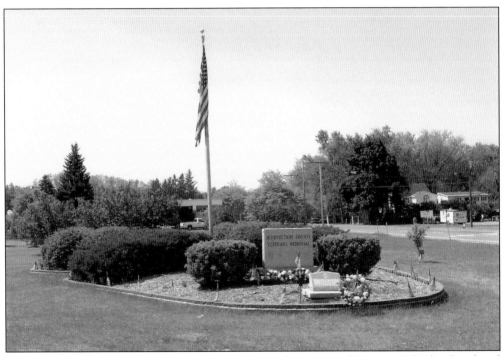

The Schenectady County Veterans Memorial is on the corner of Freeman's Bridge Road and Route 50. On the stone is written, "Mayfair Glenville VFW Post 4660 Chartered 1969 dedicated to all veterans." This is Glenville's newest park.

Seven

TRANSPORTATION

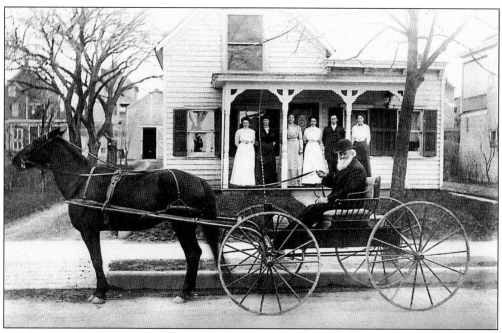

Dan Slover is in his carriage in front of his house at 212 Mohawk Avenue. Dan loved riding his horses down Mohawk Avenue, often racing his friends. On the porch are his children Rosella, Elna, Cora, Caroline, Roy, and Edith.

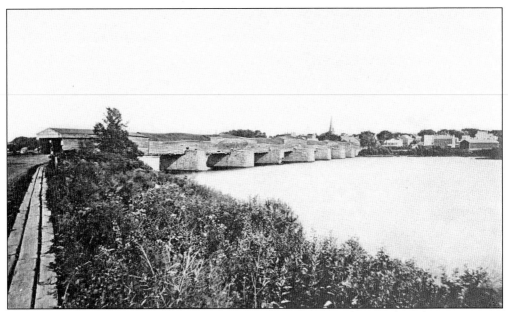

This wooden covered bridge connected Washington Avenue in Schenectady with Scotia. It was built in 1808 and was replaced by the Iron Bridge in 1874. The bridge was built by the Mohawk Turnpike and Bridge Company and designed by Theodore Burr.

The covered bridge seen from the Scotia side was part of the Mohawk Turnpike, which spanned a distance of 80 miles and connected Schenectady to Rome, New York. The turnpike featured a tavern at every mile. The DeGraff Tavern is shown on the left.

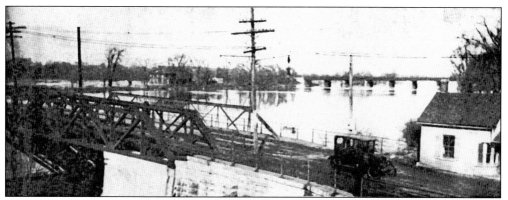

When the Iron Bridge replaced the covered bridge, the town of Glenville sold pieces of the old bridge, some of which were used as matchsticks. Residents and taxpayers were exempt from paying tolls whenever they crossed the bridge.

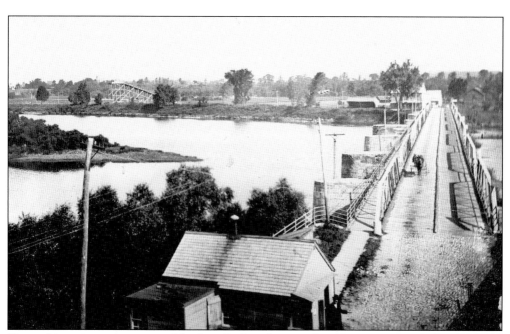

Pictured here is another view of the Iron Bridge, showing the toboggan run in Collins Park.

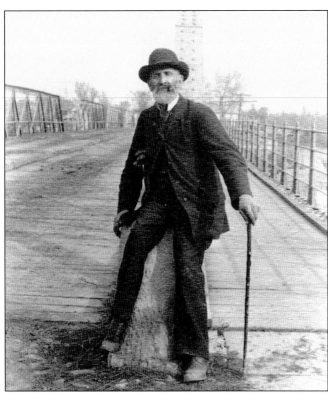

John Colland, the toll collector, stands near the Iron Bridge. This picture dates from 1892.

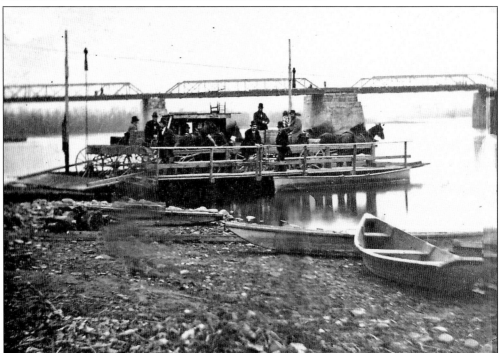

This ancient ferry was put into service while the 1874 Iron Bridge was under construction. The ferry ran from the foot of Governors Lane in Schenectady to the Glenville shore.

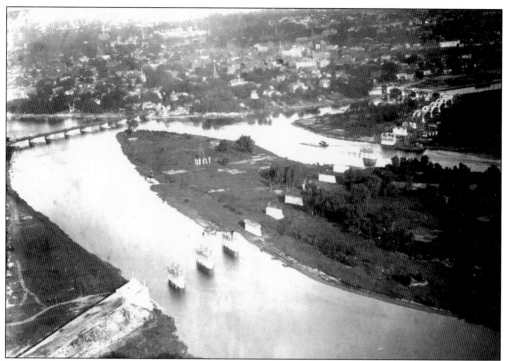

Here is an aerial view seen from the Scotia side of the Western Gateway Bridge, which was under construction in 1924. The Iron Bridge can be seen in the background.

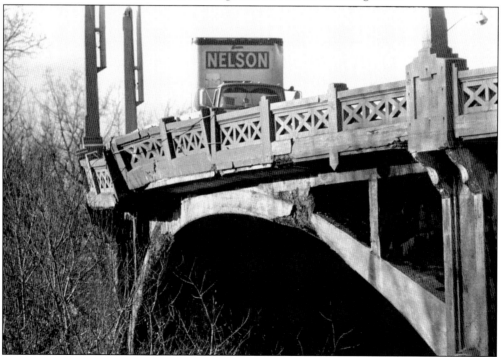

An accident occurred in 1971 on the Western Gateway Bridge. This bridge, built in 1924, was demolished in 1974 to make way for the current bridge connecting Schenectady and Scotia.

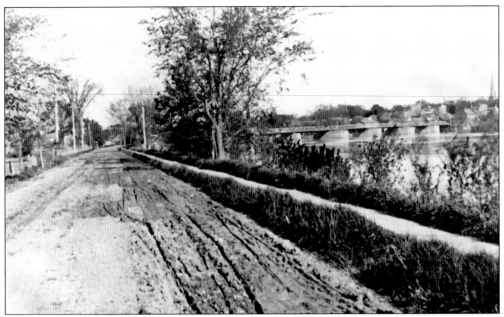

The Scotia dike (Schonowe Avenue) is shown here in the early 1890s. This became the trolley route from Scotia to Schenectady. The dike flooded annually during the spring thaw.

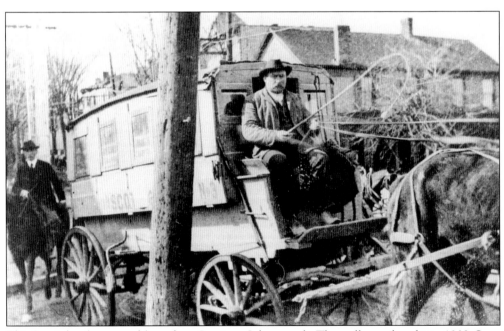

This Scotia bus (stagecoach) ran from Scotia to Schenectady. The trolley replaced it in 1902. Seen here driving the trolley is Livingston T. B. Sanders. Walter Hallenbeck is riding behind him.

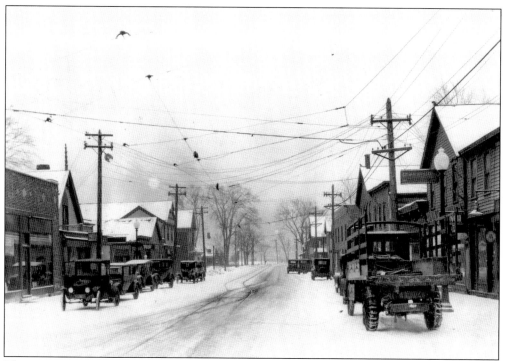

This is a winter scene on Mohawk Avenue. Notice the trolley tracks and the overhead wires that provide power to the trolley.

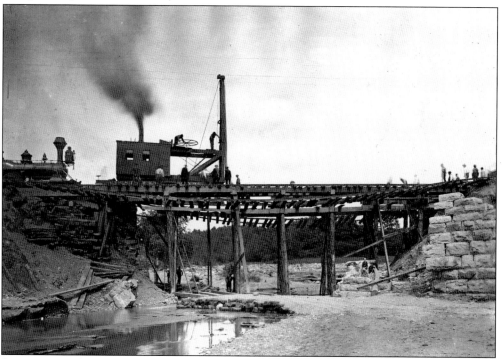

Steam-powered machinery was used to repair the railroad bridge over Washout Creek. This picture shows the damage from a cloudburst on August 12, 1885.

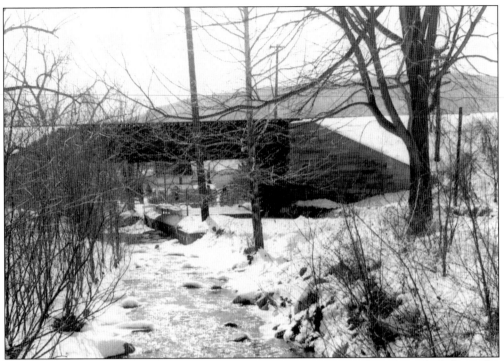

Washout Creek, shown in this 1961 photograph, runs down from the Glenville hills to the Mohawk River.

The New York Central Railroad ran along old Route 5. This view shows a steam locomotive taking on water in Hoffmans.

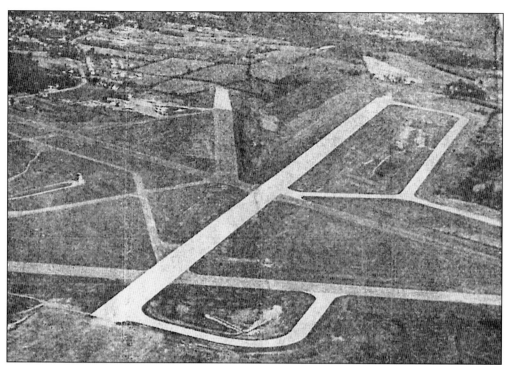

The Schenectady County Airport was officially opened on June 1, 1927, when a Waco biplane set down at 11:04. The airport was entirely financed by the sale of $100,000 worth of bonds to the general public.

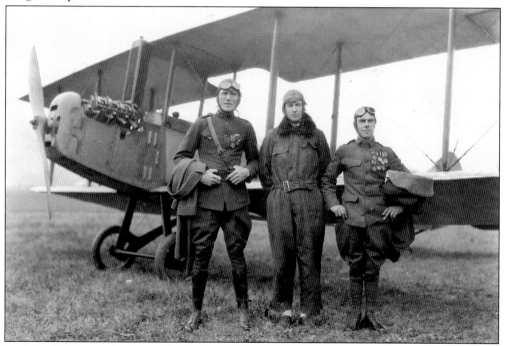

Lt. J. Fred Johnson, Lt. Victor Rickard, and Sgt. Everett D. Lee stand before an early biplane. Victor Rickard, who became a flyer in 1918, was an early barnstormer.

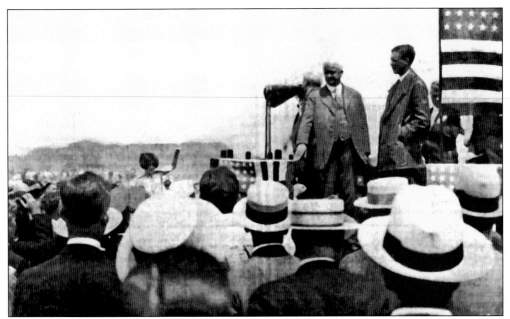

On July 28, 1927, Charles Lindbergh visited the Schenectady County Airport as part of his tour of 500 U.S. cities. Over 20,000 people greeted the popular hero.

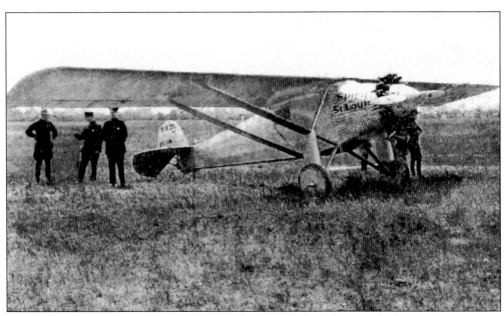

Local police are shown guarding the *Spirit of St. Louis* at the Schenectady County Airport.

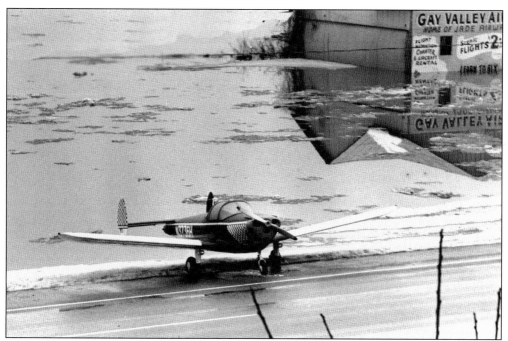

The Gay Valley Airport (now known as the Mohawk Valley Airport) is located on Route 5 west of Scotia. It is a popular spot for skydiving. This scene shows the airport during the 1973 flood. The land was the Barhydt broomcorn fields in the 19th century.

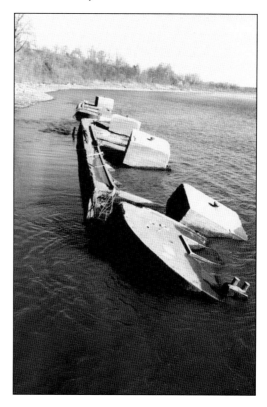

Concrete boats were built in 1918 due to the shortage of steel during World War I. The use of concrete never caught on because the barges were easily damaged.

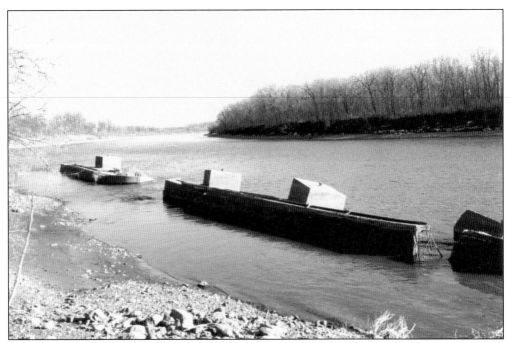

The barges shown here were used commercially for only three or four years. Some were deliberately sunk to create walls at various locks on the Barge Canal. Remains of the concrete hulks can be seen at Lock 9 on the Scotia side.

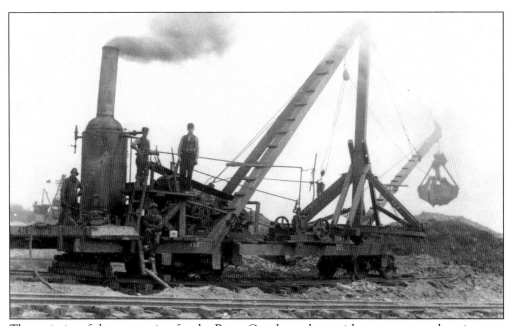

The majority of the excavation for the Barge Canal was done with steam-powered equipment, such as the clamshell shown in this c. 1906 photograph.

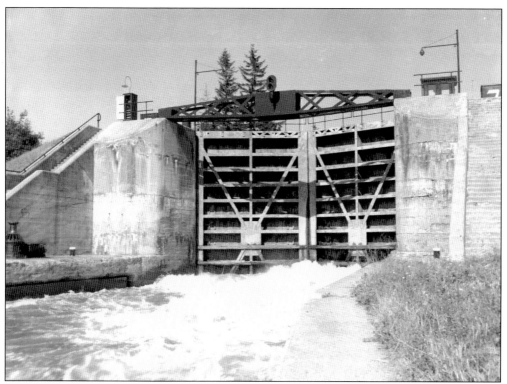

Lock gates were used to control water levels in the locks. Lock 9, shown here, is located just west of the village of Scotia.

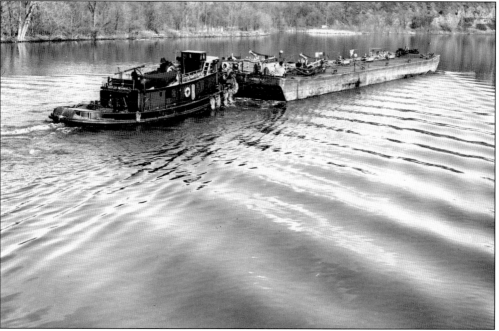

A tugboat is pushing a barge on the Barge Canal, which is part of the Mohawk River.

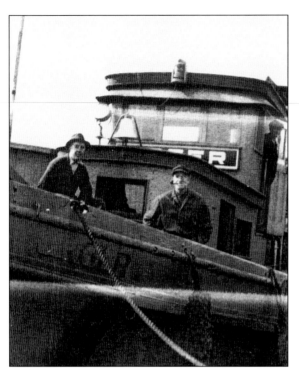

The *Urger*, a tugboat built in 1901, is still used for ceremonial and educational programs. In this photograph, Tom Golden is on the right.

John Dawson used this wooden boat to ferry people to work on the Barge Canal locks from 1915 to 1918. Dawson is pictured with his son-in-law in 1940.

Eight

HAMLETS

The Harmanus Hagadorn house, on Maple Street in Alplaus, was built in 1689. *Alplaus* means "the place of the eels" in Dutch, and the American Indians used the area for growing crops of maize. The French supposedly used Alplaus as a camping ground during the French and Indian Wars.

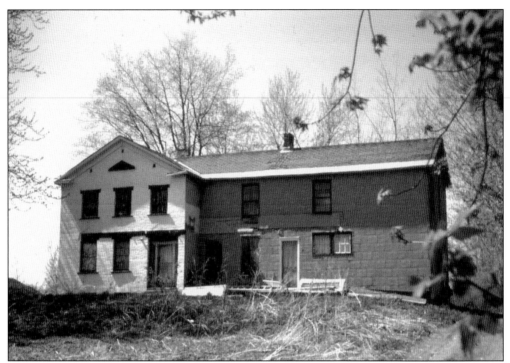

The William Stevens family had a house on Mohawk Avenue in Alplaus about 1780. This picture was taken in 1976.

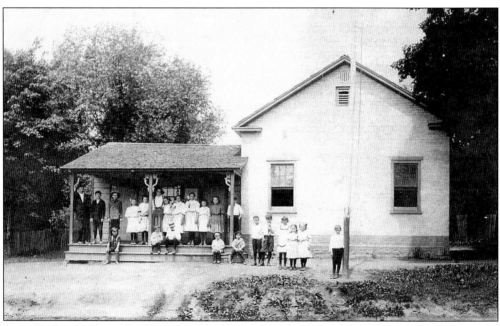

In 1847, the Alplaus schoolhouse was built. The last class was held here in 1907. In 1971, the building was purchased by Donald and Mary Lib Woodin.

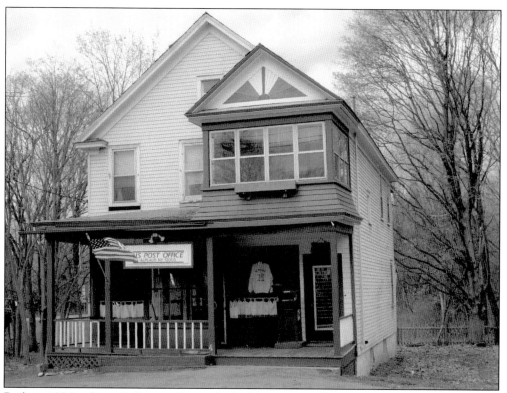

Built in 1906 as Boyce's Grocery Store, the building pictured here on Alplaus Avenue went on to become the town's post office, bicycle shop, gift shop, and insurance agency.

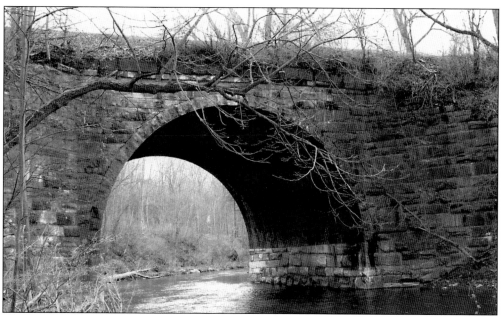

This structure is located in the woods off Bruce Street in Alplaus. It is believed to be an old trolley overpass.

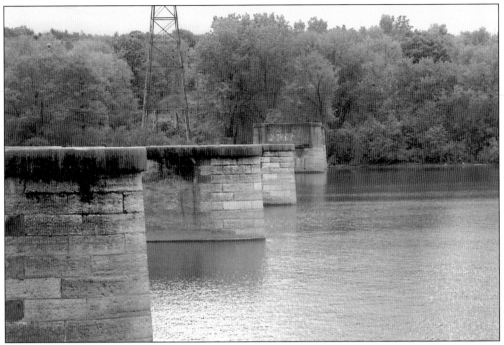

The Schenectady-Saratoga trolley bridge piers are pictured here. The trolley had many stops along the line with small buildings that were placed periodically along the route to serve as shelter for waiting passengers.

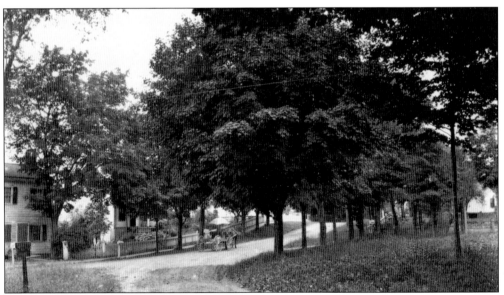

This photograph of Glenville Village was taken from North Road in the early 20th century. The image shows a treelined dirt road with a horse-drawn buggy. An umbrella shades the driver of the buggy.

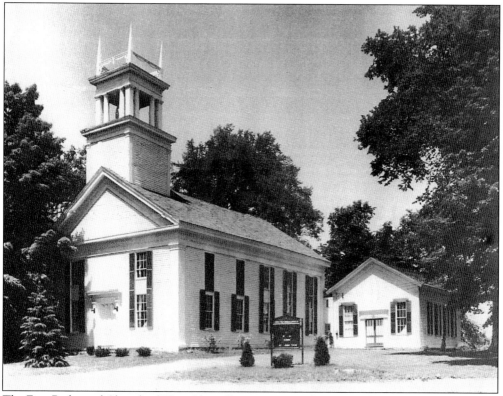

The First Reformed Church of West Glenville was organized in 1812. The picture shows how the church appeared after it was remodeled for $6,000 in 1871. In 1964, the church was destroyed by fire but was immediately rebuilt.

The Vander Veer House is on Touareuna Road in West Glenville. The first deed to the land was dated 1797. The Vander Veer family came from Holland on the good ship *Otter* in 1659, but they did not settle here until after the Revolutionary War. The house remains about as it was when built.

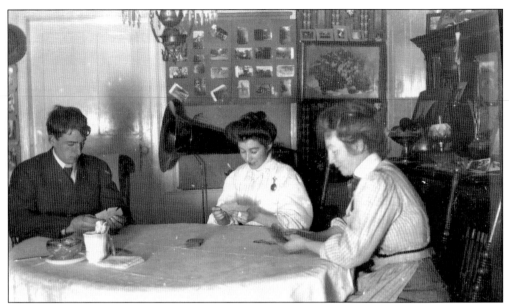

These people playing cards are Clarence Vander Veer, Gertrude Jones, and Mrs. John Vander Veer. Note the old phonograph in the background.

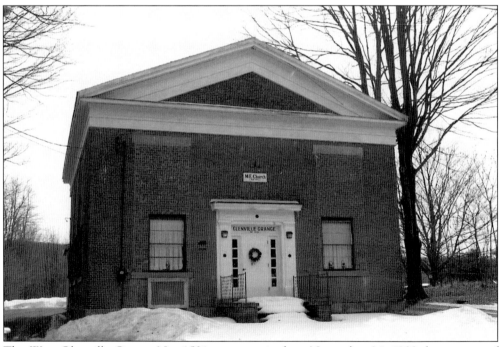

The West Glenville Grange No. 1531 was organized on November 24, 1933, by a group of 22 people. The first meeting was held in the chapel of the Glenville Reformed Church in 1933. Two years later, the Grange purchased the old Methodist church on West Glenville Road to serve as their hall.

Deadman's Curve, in the hamlet of Hoffmans, was on Amsterdam Road (Route 5). The curve was straightened when Route 5 was widened in the 1960s.

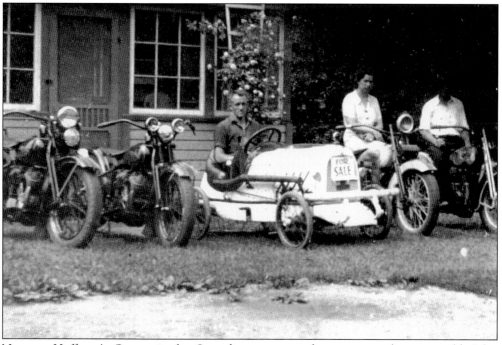

Next to Hoffman's Garage is the Snowden property where motorcycles were sold. John Splittsberger is sitting in the car.

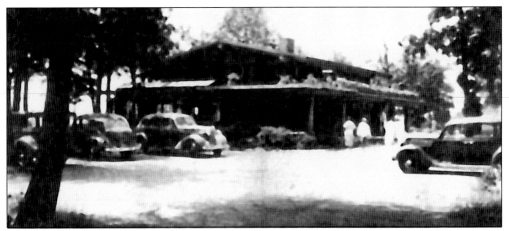

Hixson's Riverwood Inn was in Hoffmans on Route 5. It advertised "Good food served attractively." The restaurant overlooked the Mohawk River and had shaded lawns.

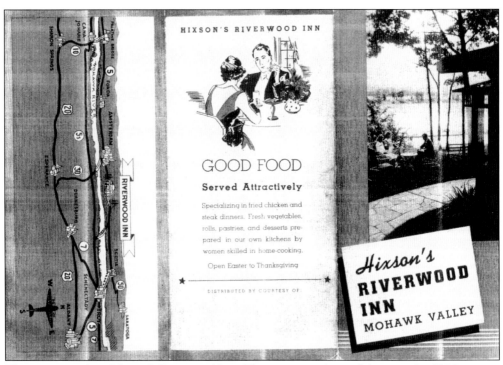

This is a menu from Hixson's Riverwood Inn. The restaurant burned down in the 1950s.

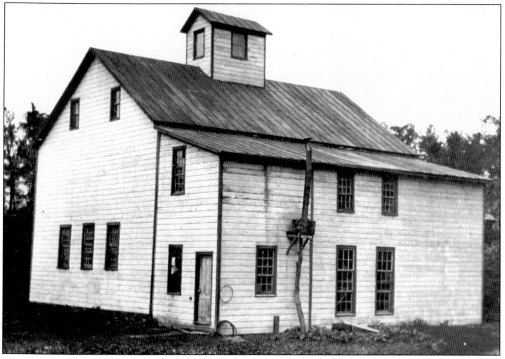

High Mills factory was used during the broom-making era of the 1800s. It was located in High Mills near Route 50.

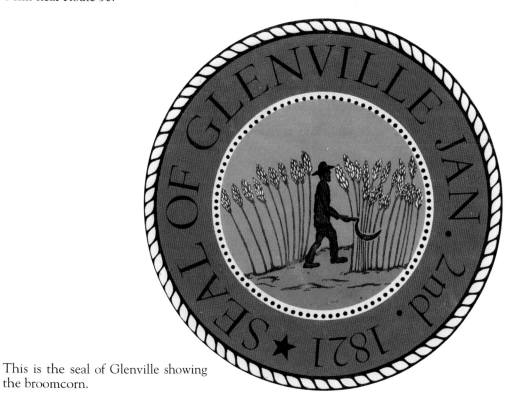

This is the seal of Glenville showing the broomcorn.

Acknowledgments

Photographs for this book were generously provided by Joan Szablewski, Glenville History Center; Cindy Seacord, Efner History Center; Donald Keefer, former Glenville town historian; Dick Whalen, Rotterdam town historian; Gary and Kim Mabee, Dale and Jim Smith, Alan Hart, and the Grems-Doolittle Library of the Schenectady County Historical Society. Our thanks go to the many individuals who assisted in identifying and dating the photographs.

Beth Pfaffenbach (chief editor), Jim Eignor (photography editor), Carol Lewis, Ann Eignor, Scott Haefner, Mary Liebers, and Sally Van Schaick formed the book committee. Joan Szablewski, Glenville town historian, shared not only photographs but also her wealth of knowledge. The support of the Schenectady County Historical Society Board of Trustees and of Virginia Bolen, librarian of the Grems-Doolittle Library is greatly appreciated.